Dalí

Page 6: Self-Portrait, c. 1921 Oil on canvas. 36.8 x 41.8 cm The Salvador Dalí Museum, St Petersburg (FL)

Designed by :
Baseline Co Ltd
19-25 Nguyen Hue
Bitexco Building, Floor 11
District 1, Ho Chi Minh City
Vietnam

ISBN 1-84013-748-7

- © 2004, Sirrocco, London, UK
- © 2004, Dalí Estate/ Artist Rights Society, New York, USA

Published in 2004 by Grange Books an imprint of Grange Books Plc The Grange Kingsnorth Industrial Estate Hoo, nr Rochester, Kent ME3 9ND www.grangebooks.co.uk

All rights reserved

No part of this publication may be reproduced or adapted without the permission of the copyright holder, throughout the world. Unless otherwise specified, copyrights on the works reproduced lies with the respective photographers. Despite intensive research, it has not always been possible to establish copyright ownership. Where this is the case we would appreciate notification

Printed in China by Everbest Printing Co Ltd

"In view of the tangle of riddles, Dalí has emerged to conquer the world of painting, and out of this fight has brought us something more valuable than gold. He has opened up new horizons to spread them before us, but above all has given us something more tangible: Salvador Dalí."

- Julien Green

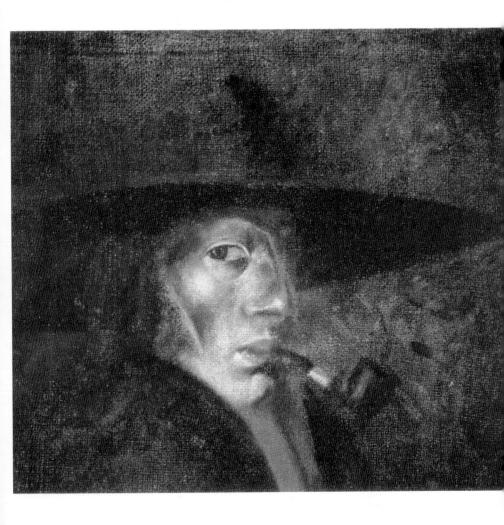

Biography

1903 August 1, death of Dali's elder brother, Salvador Galo Anselmo, at the age of two from gastroenteritis. May 11, birth of Salvadore Felipe Jacinto Dalí in Figueras, a small fishing village in Spain. The family name, 1904 unusual in Spain, stems from the Catalan word "adalil", which in turn has its roots in the Arabic and means "leader" 1910 Dalí's grandmother Maria Ana Ferrés and aunt Catalina move into Dalí's family home. 1914 Dalí's oldest existing works are dated from 1914. 1916 Aged twelve, Dalí was sent on holiday to the "Mulí de la Torre" estate of some family friends, the Pitchots a few kilometers from Figueras. A place which became a place of magic for the then young Salvador. 1918 In winter, Dalí took art in a group exhibition of artists from Figueras. In the local newspaper, the fourteen-year-old was celebrated as an up-and-coming "master painter". 1919 Summer spent in Cadaqués, his father's birthplace on the Costa Brava, in a little holiday house. February 6. death of Felipa Doménech, Dalí's mother. The father promptly married his deceased wife's sister, 1921 Catalin, who had already been living in his household for the last eleven years. 1922 Accompanied by his father and his sister Ana Maria, Dalí traveled to the entrance examination at the art school in Madrid. After the examination commission accepted him, he moved into a room at the "Residencia de Estudiantes", a student residential and cultural centre based on the Oxford and Cambridge model. Sigmund Freud's The Interpretation of Dreams was published. Dalí began reading it immediately and used it to 1923 analyse his own dreams. Meeting between Dalí and Federico Garcia Lorca. 1924 At the beginning of his second year of studies, Dalí was gated from the academy for twelve months. Dalí returned to Figueras where his father stood against the dictator Miguel Primo de Rivera for the elections. In October, Dalí returned to the academy and continued his bohemian life. In May, Dalí took part in the "First Iberian Artists' Art-Salon" with ten paintings, amongst them a portrait of his 1925 friend Luis Buñuel that he had painted in 1924. Dalí and Lorca traveled together to Figueras during the Easter holidays and developed a close relationship as from then. In November, the Dalmau gallery in Barcelona presented the first single-showing of Dali's paintings. Dalí traveled to Paris to visit Picasso in his aprtment in the rue de la Boétie. Garcia Lorca wrote the Ode to 1926 Salvador Dalí. Painting of Still Life (Invitation to Sleep). From a photo Ana Maria had taken of the sleeping poet in 1925, Dalí painted Garcia Lorca's head in the style of a Roman bust, where the plastic qualities in relief and outline are broken down into shadows and the portrayal of features. Dalí and Lorca begin to work on a piece together, Mariana Pineda. Dalí began working on the painting Honey is Sweeter than Blood. The painting, Basket of Bread, was exhibited at the Carnegie Museum of Art in Pittsburgh. 1927 June 24, première of Maria Pineda. In the summer, Dalí published a drawing titled Holy Sebastian in the magazine "L'Amic de les Arts", dedicated to Garcia Lorca. Drawing of the title-picture for "Gallo", the magazine that Garcia Lorca published in Granada. Writing of the scipt 1928 for Un chien andalou - An Andalusian Dog. 1929 Dalí travelled to Paris to see the film Un chien and alou being shot. During his stay there, Dalí also signed a contract with the gallerist Camille Goemans. In the summer, Dalí met Gala Éluard in Cadaqués and they both fell in love with one another. End of November, a dispute broke out between Dalí and his father told him the family wished to have nothing more to do with him. Painting of The Great Masturbator. 1930 Gala published Dalí's La femme visible - The Visible Woman, a gathering of many of his thoughts on the double picture. October 22, presentation of The Golden Age - for which Dalí had made written contributions - to a discerning audience among which Gertrude Stein, Pablo Picasso, Marcel Duchamp, André Malraux and Man Ray. Purchased of The Persistence of Memory, by the New York Museum of Modern Art after it had been exhibited in 1932 Julien Levy's gallery that year.

- 1933 Julien Levy was the first to devote a whole exhibition to Dalí.
- Dalí exhibited his painting *The Riddle of William Tell* in the Salon of the Indépendants early that year. Dalí and Lorca met for the last time in Barcelona. Two years later, shortly after the beginning of the Spanish civil war, Garcia Lorca was murdered by Franco's soldiers. Dalí and Buñuel's friendship came to an end. In November, Dalí and Gala travelled to the United States for the first time
- 1935 In January, the Dalís return to Paris and were greeted with the news that they had caused a scandal in New York at a parting celebration at the elegant New York restaurant, Coq Rouge.
- 1936-1939 More travels to the United States. In between times they lived in Italy and the south of France.
- 1936 On his second trip to New York in December 1936, Time magazine devoted the title page to him. It featured a portrait that Man Ray had taken of him.
- On May 21, World Fair in New York. As subject, Dalí chose the *Dream of Venus*. End of the year, Dalí led the Metropolitan Opera in his first dramatic work titled, *Bacchantal*, based on motifs from Wagner's *Tristan and Isolde*.
- The Dalis moved into a house at Pebble Beach not far from Los Angeles. Painting of Soft Self-Portrait with Fried Bacon. October 8, Labyrinth was premiered by the Ballets russes at the Metropolitan Opera.
- Halsmann designed the dust-jacket for Dalí's autobiography which appeared that year in English. End of the year, the New York Museum of Modern Art put on a retrospective of Dalí's work featuring fifty pictures and seventeen drawings. The exhibition subsequently went to eight other American cities. In December, Dalí met Eleanor and Reynolds Morse. Four months later the Morses bought their first "Dalí" for 1,200 dollars: Daddy Longlegs of the Evenina Hope!
- Director Alfred Hitchcock brought Dalí into the studio to create the dream-sequence for his psychoanalytically inspired film Spellbound.
- 1946 Dalí painted his first piece of work with a religious motive.
- 1948 Dali converted to the Roman Catholic church. In the same year he returned once more to Europe with Gala and moved back into their house in Port Lligat.
- Salvador painted the first version of the Madonna of Port Lligat. As a model for the painting he used Piero della Francesca's Madonna with Child from the 15th century.
- Dalí created the dream-sequence for Vincente Minelli's comedy The Bride's Father.
- 1951 September 3, Dalí and Gala appeared as seven-metre tall giants at a ball in Venice.
- 1955 Dalí transferred his atelier for some days to the rhinoceros enclosure at the zoo in Vincenne, a suburb of Paris, in order to work on his paranoic-critical version of the Bobbin-Lace Maker of Vermeer.
- Dalí married Gala (Jelena Deluwina Diakonoff of her real name, and called "Gradiva" by Dalí), a Russian born woman and widow of French poet Paul Éluard. She stayed by Dalí's side until her death in 1982 and acted as his muse, model and manager.
- 1967 Dalí bought the half-ruined Chateau Pubol for Gala.
- 1974 The seventy-year-old Dalí opened his "Teatro-Museo"
- 1976 Enrique Sabater took over Dalí's general affairs management and quickly succeeded in becoming a multi-millionaire at Dalí's expense.
- 1979 The Georges-Pompidou Centre in Paris devoted an extensive retrospective to Dalí.
- 1980's Dalí became ill with Parkinson's Disease
- The Morses acquired over four hundred of his works, and amongst these approximately ninety paintings. They built a museum in St Petersburg, Florida for their collection in 1982.
- 1983 He painted his last picture: The Swallow's Tail
- 1989 January 23, death of Salvador Felipe Jacinto Dalí.
- 1994 Exhibition on Dalí's formative years.

A the age of 37, Salvador Dalí wrote his autobiography. Titled *The Secret Life of Salvador Dalí*, the Spanish painter portrays his childhood, his student days in Madrid, and the early years of his fame in Paris up to his leaving to go to the USA in 1940. The exactness of his descriptions are doubtful in more than one place. Dates are very often incorrect, and many childhood experiences fit too perfectly into the story of his life.

Dutch Interior (Copy after Manuel Benedito)

1914 oil on canvas, 16 x 20 cm Joaquín Vila Moner Collection, Figueras

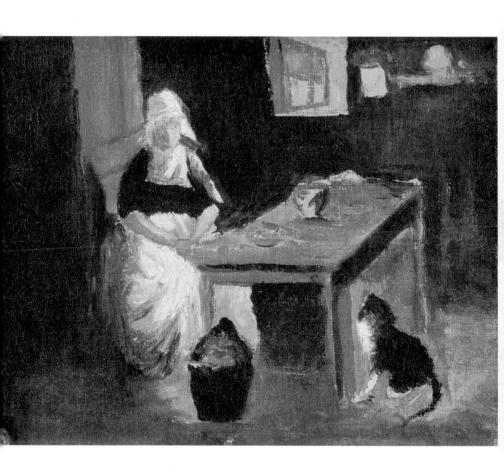

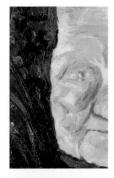

The picture that Dalí drew of himself in 1942, and further developed in the years up to his death in 1989, shows an eccentric person, most at ease when placed in posed settings. Despite this tendency, Dalí often revealed intimate details of his life in front of the camera. This act of self-disclosure, as Dalí explains in his autobiography, is a form of vivisection, a laying bare of the living body carried out in the name of pure narcissism.

Portrait of Lucia

1918 oil on canvas, 43.5 x 33 cm private collection

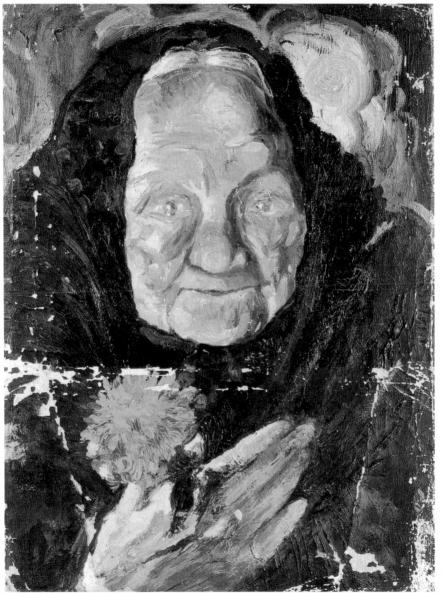

The more Dalí showed himself in public, the more he concealed himself. His masks became ever larger and ever more magnificent: he referred to himself as "genius" and "god-like". Whoever the person behind Dalí really was, it remains a mystery.

Dalí's memories appear to begin two months before his birth on May 11th, 1904.

Self-Portrait in the Studio

c. 1919 oil on canvas, 27 x 21 cm Salvador Dalí Museum, St Petersburg (Florida)

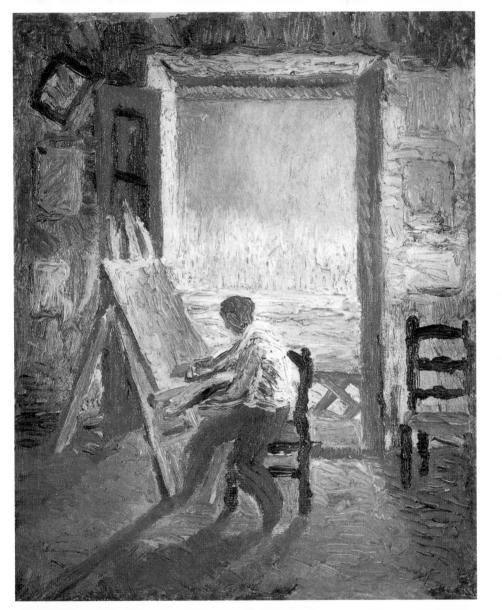

Recalling this period, he describes the "intra-uterine paradise" defined by "colours of Hell, that are red, orange, yellow and bluish, the colour of flames, of fire; above all it was warm, still, soft, symmetrical, doubled and sticky." His most striking memory of birth, of his expulsion from paradise into the bright, cold world, consists of two eggs in the form of mirrors floating in mid-air, the whites of which are phosphorising: "These eggs of fire finally merged together with a very soft amorphous white paste, characterized by their extreme elasticity.

Port of Cadaqués at Night

1919

oil on canvas, 18.7 x 24.2 cm Salvador Dalí Museum, St Petersburg (Florida)

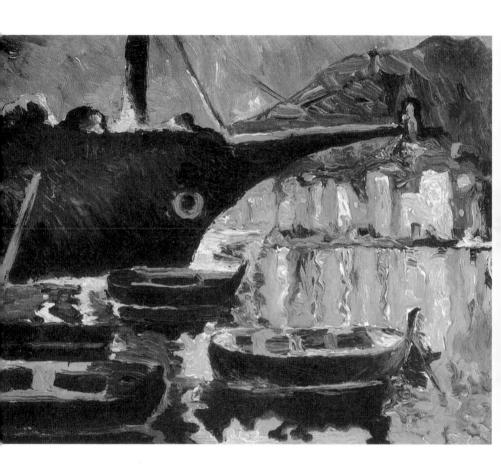

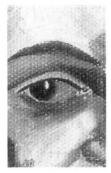

Technical objects were to become my biggest enemy later on, and as for watches, they had to be soft or not at all."

Dalí's life is overshadowed by the death of his brother. On August 1st, 1903, the first-born child of the family, scarcely two years old, died from gastroenteritis. The child Salvador sees himself as nothing more than a substitute for the dead brother: "Throughout the whole of my childhood and youth I lived with the perception that I was a part of my dead brother.

Portrait of José M. Torres

c. 1920 oil on canvas, 49.5 x 39.5 cm Museum of Modern Art, Barcelona

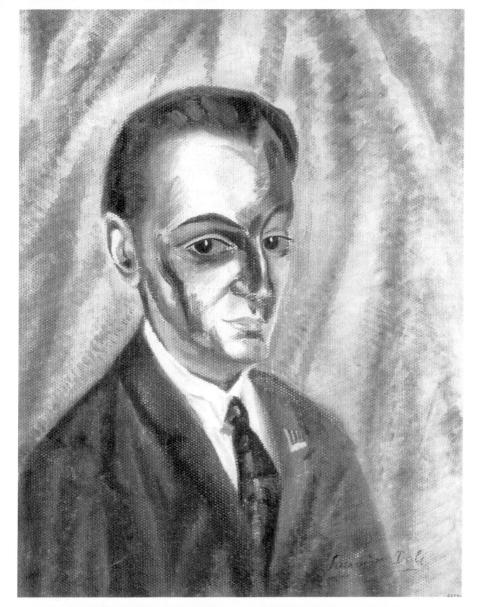

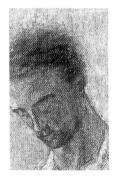

That is, in my body and my soul, I carried the clinging carcass of this dead brother because my parents were constantly speaking about the other Salvador." Out of fear that the second-born child could also sicken and die, Salvador was particularly cosseted and spoiled. He was surrounded by a cocoon of female attention, not just spun by his mother Felipa Doménech Ferrés, but also later by his grandmother Maria Ana Ferrés and his aunt Catalina.

Portrait of the Cellist Ricardo Pichot

1920

oil on canvas, 61.5 x 49 cm private collection, Cadaqués

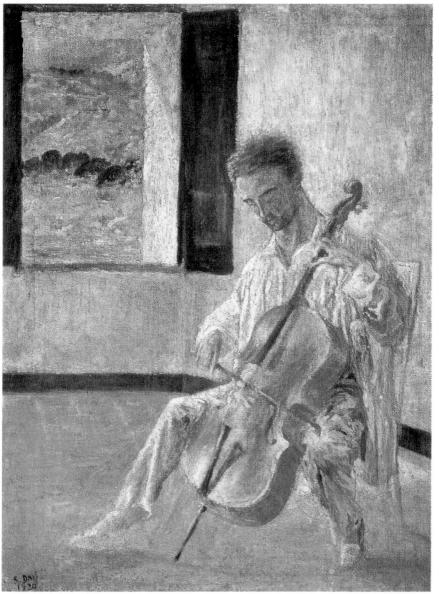

Dalí reported that his mother continually admonished him to wear a scarf when he went outdoors. If he got sick, he enjoyed being allowed to remain in bed. Dalí's sister Ana Maria, four years younger, writes in her book, Salvador Dalí visto por su hermana (Salvador Dalí, Seen Through the Eyes of his Sister), that their mother only rarely let Salvador out of her sight and frequently kept watch at his bedside at night, for when he suddenly awoke, startled out of sleep, to find himself alone, he would start a terrible fuss.

Portrait of Hortensia, Peasant Woman from Cadaqués

> oil on canvas, 35 x 26 cm private collection

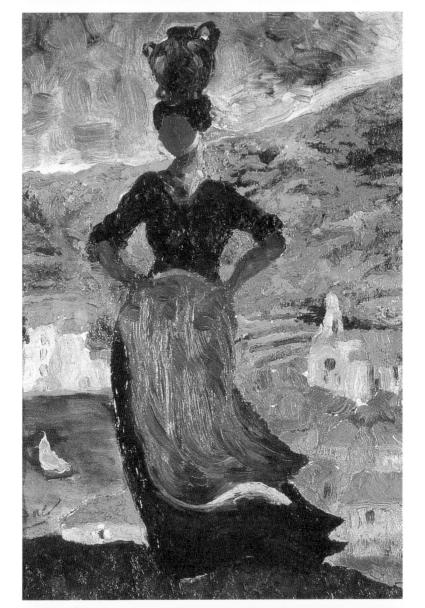

Salvador enjoyed the company of the women and especially that of the eldest, his grandmother and Lucia. He had very little contact with children of his own age. He often played alone. He would disguise himself as a king and observe himself in the mirror: "With my crown, a cape thrown over my shoulders, and otherwise completely naked. Then I pressed my genitals back between my thighs, in order to look as much like a girl as possible. Even then I admired three things: weakness, age and luxury."

Self-Portrait with the Neck of Raphael

1920-1921 oil on canvas, 41.5 x 53 cm Gala-Salvador Dalí Foundation, Figueras

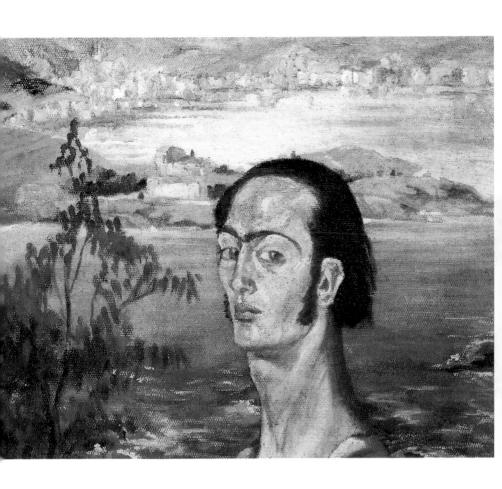

Dalí's mother loved him unreservedly, even lionized him. With his father, Dalí enjoyed a different type of relationship. Salvador Dalí y Cusi was a notary in the Catalan market-town of Figueras, near the Spanish-French border. An anti-Catholic free thinker, he decided not to send his son Salvador to a church school, as would have befitted his social status, but to a state school.

Landscape near Cadaqués

1920-1921 oil on canvas, 31 x 34 cm Gala-Salvador Dalí Foundation, Figueras

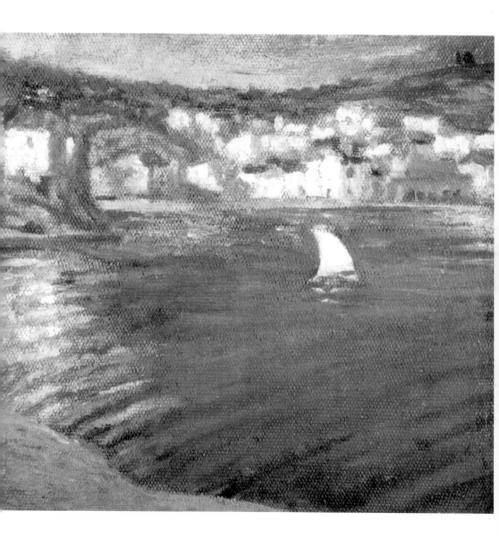

Only when Salvador failed to reach the required standard in the first year did his father allow him to transfer to a Catholic private school of the French "La Salle" order. There, among other things, the eight-year-old learned French, which was later to become his second mother tongue, and received his first lessons in painting and drawing.

Self-Portrait

c. 1921 oil on canvas. 36.8 x 41.8 cm Salvador Dalí Museum, St Petersburg (Florida)

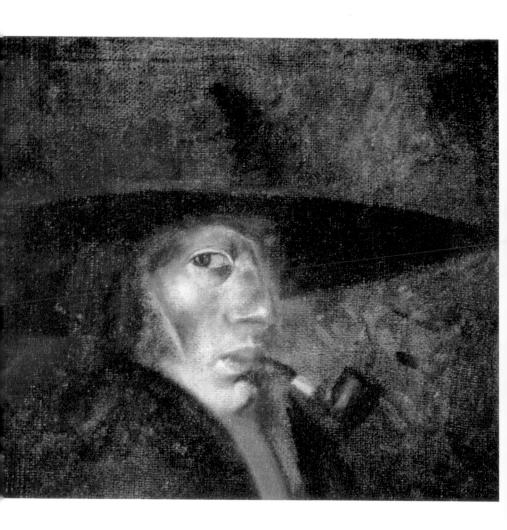

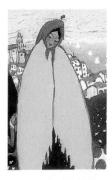

At about the same time as Salvador was receiving his first lessons from the brothers of the "La Salle" Order, he set-up his first atelier in the old, disused washroom in the attic of his family home: "I placed my chair in the concrete basin and arranged the high-standing wooden board (that protects washerwomen's clothing from the water) horizontally across it so that the basin was half covered.

Festival at San Sebastián

1921 gouache on cardboard, 52 x 75 cm Gala-Salvador Dalí Foundation, Figueras

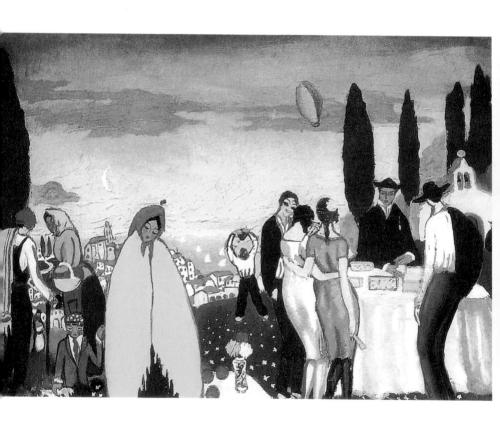

This was my workbench!" Dalí's oldest existing works date from the year 1914. They are small-format watercolours, landscape studies of the area around Figueras.

Oil paintings by the eleven-year-old also exist, mostly as copies of masterpieces which he found in his father's well-stocked collection of art books. For Salvador, the atelier became the "sanctuary" of his loneliness.

Scene in Cabaret

1922 oil on canvas, 52 x 41 cm Bénédicte Petit Collection, Paris

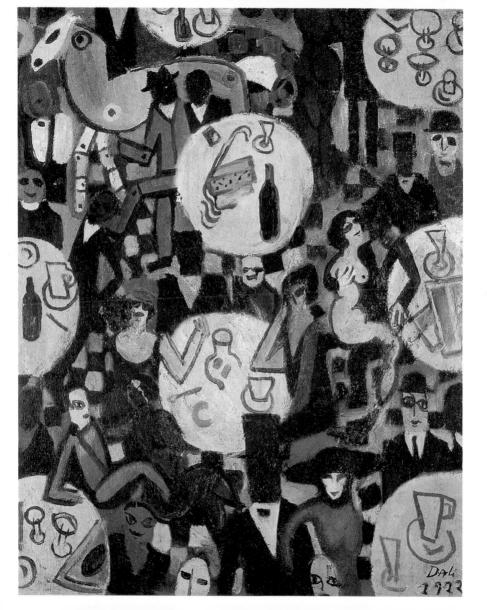

In the laundry-room atelier the little king tried out a new costume: "I started to test myself and to observe; as I performed hilarious eyewinking antics accompanied by a subliminal spiteful smile, at the edge of my mind, I knew, vague as it was, that I was in the process of playing the role of a genius. Ah Salvador Dalí! You know it now: if you play the role of a genius, you will also become one!"

Family Scene

1923

oil and gouache on coardboard, 105 x 75 cm Gala-Salvador Dalí Foundation, Figueras

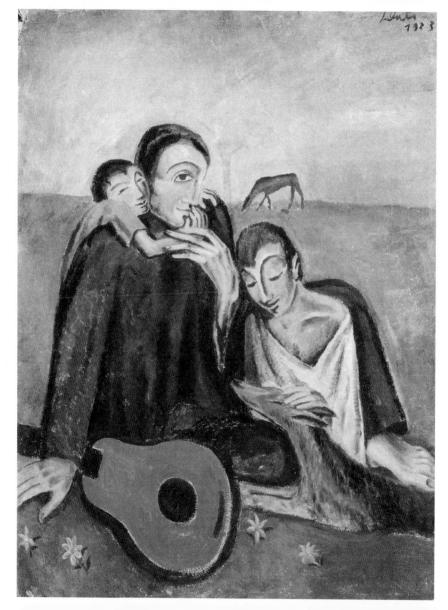

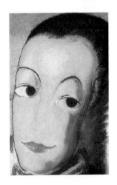

Later Dalí analysed his behavior: "In order to wrest myself from my dead brother, I had to play the genius so as to ensure that at every moment I was not in fact him, that I was not dead; as such, I was forced to put on all sorts of eccentric poses."

Salvador's attempts to distance himself from his dead brother went so far that he believed himself immortal. Descending the stairs one day at school, it suddenly occured to him that he should let himself fall.

The Sick Child (Self-Portrait in Cadaqués)

c. 1923

oil and gouache on cardboard, $57 \times 51 \text{ cm}$ Salvador Dalí Museum, St Petersburg (Florida)

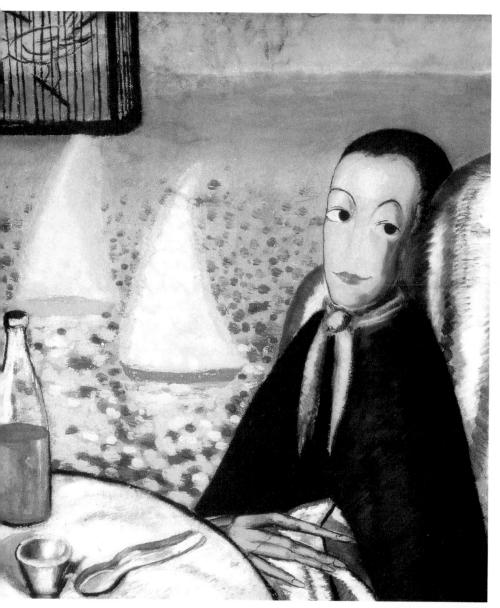

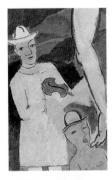

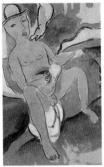

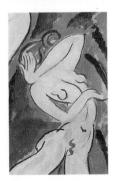

But at the very last moment fear held him back. However, he worked out a plan of action for the next day: "At the very moment I was descending the stairs with all my classmates, I did a fantastic leap into the void, and landing on the steps below bowled over and over until I finally reached the bottom. The effect on the other boys and the teachers who ran over to help me was enormous."

Satirical Composition ("The Dance" by Matisse)

1923

gouache on cardboard, 138 x 105 cm Gala-Salvador Dalí Foundation, Figueras

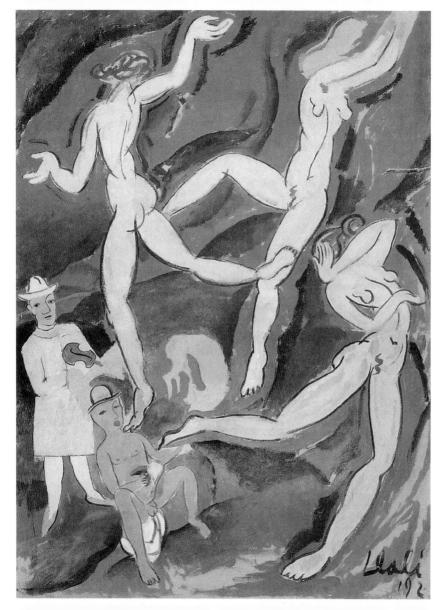

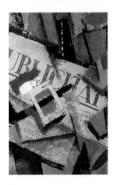

The ability to attract the attention of the others, and to be subsequently admired by them afforded the little king Salvador untold enjoyment. However, he did prefer it when his "entourage" kept their distance. From his window in the laundry-room atelier he spied on the other children, particularly the schoolgirls from the neighbouring school.

Cubist Self-Portrait

1923

gouache and collage on cardboard 104.9 x 74.2 cm Reina Sofia National Museum, Madrid

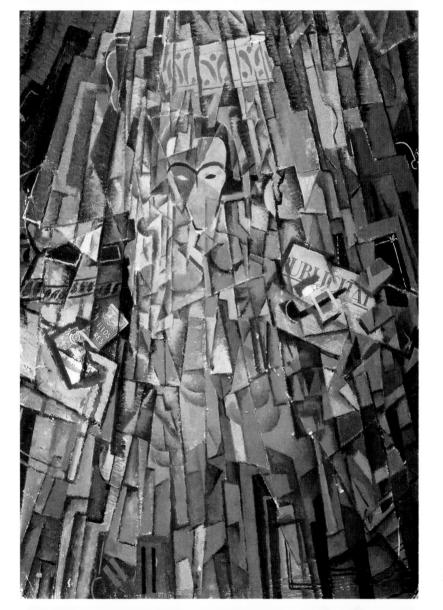

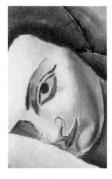

In the summer of 1916, the twelve-year-old was sent on holiday to the estate of some family friends, the Pitchots. The "Mulí de la Torre" estate, named after its tower-mill, and just a few kilometers from Figueras, was to become a place of magic for Salvador. For weeks he gave himself up to his day-dreams undisturbed, a reverie for which he only had the odd single hour in Figueras in his laundry-room atelier. Most of his fantasies at this time were of an erotic nature. Eroticism and death become unified very early in Dalí's life.

Portrait of Ana María

c. 1924 oil on cardboard, 55 x 75 cm Gala-Salvador Dalí Foundation, Figueras

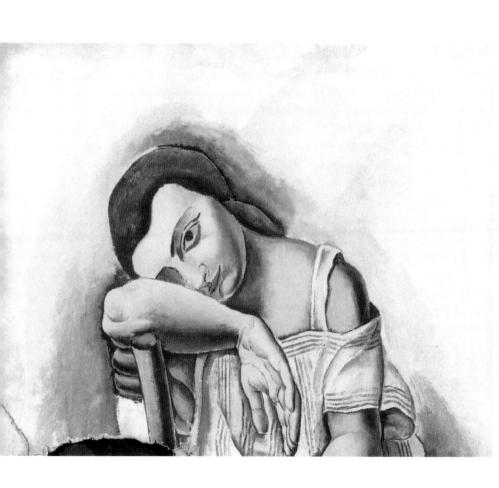

From a net of fantasies centered around eroticism, death, and disgust, Dalí only managed to save himself by his own mental agility. During puberty, and wholly without any system, he began to read through his father's extensive library. He occupied himself especially with the philosophers Voltaire, Nietzsche, Descartes, and Spinoza; but without doubt his favourite was Kant: "I loved very much to lose myself in the labyrinth of his avenues of thought, in which the ever expanding crystals of my youthful intelligence found true heavenly music reflected."

Portrait of Luis Buñuel

1924 oil on canvas, 70 x 60 cm Reina Sofia National Museum, Madrid

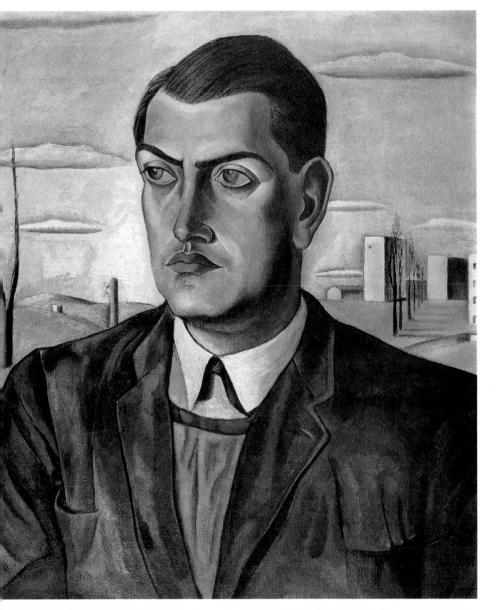

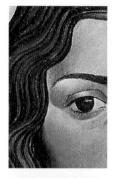

Despite this monopolisation by philosophy, Dalí also occupied himself with art history and continued his attempts at painting. His father supported him by buying him canvas, brushes, paints and magazines. However, a more important role as sponsor was taken over by Pepito Pitchot, who set up for him an atelier in a barn. Dalí painted landscapes in the impressionist style and he also developed his own ideas.

Portrait of a Girl in a Landscape

1924-1926 oil on canvas, 92 x 65 cm Gala-Salvador Dalí Foundation, Figueras

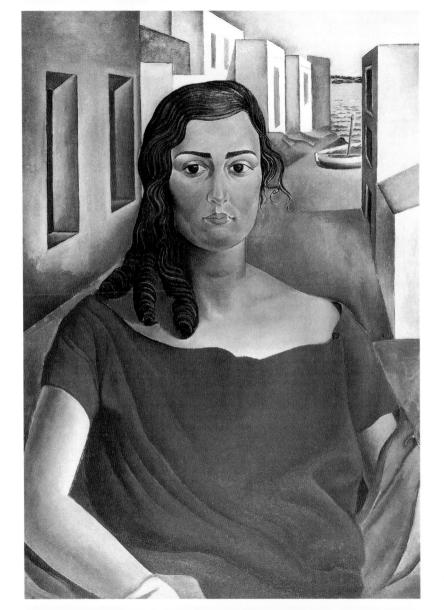

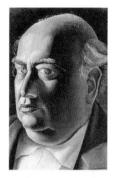

One day, for example, he attached real cherry-stems to his paintings of cherries. Pepito Pitchot was impressed by this idea; so much so that he promised to talk Señor Dalí into allowing Salvador to receive lessons in painting. In the coming school year Dalí changed to the private Marist high school. In addition, he visited Juan Nuñez's painting class at the city art school. As Dalí later stated, he owed much to this teacher. By this time the boy was convinced that he wanted to become a painter.

Portrait of My Father

1925 oil on canvas, 100 x 100 cm Museum of Modern Art, Barcelona

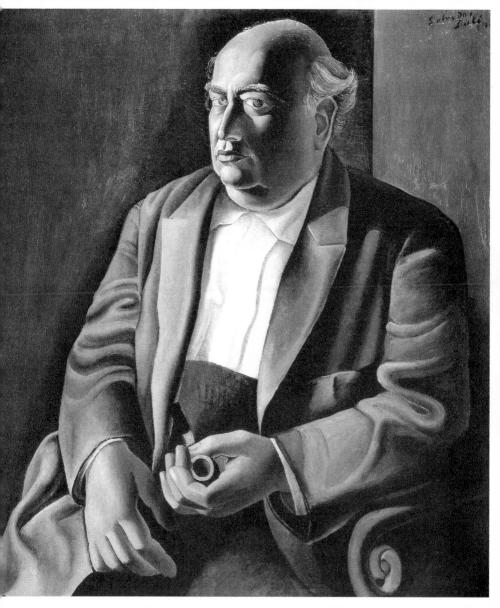

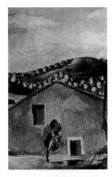

Fundamentally, his father had nothing against this; however he insisted on a formal training: first the high school diploma, then study at the vocational school of art, sculpture and graphics in Madrid. Dalí spent the summer of 1919 in Cadaqués, his father's birthplace on the Costa Brava.

The family had a little holiday house there. Cadaqués was a place which Dalí loved "with fanatical loyalty" the whole of his life.

Seated Girl from the Back

1925 oil on canvas, 103 x 73.5 cm Reina Sofia National Museum, Madrid

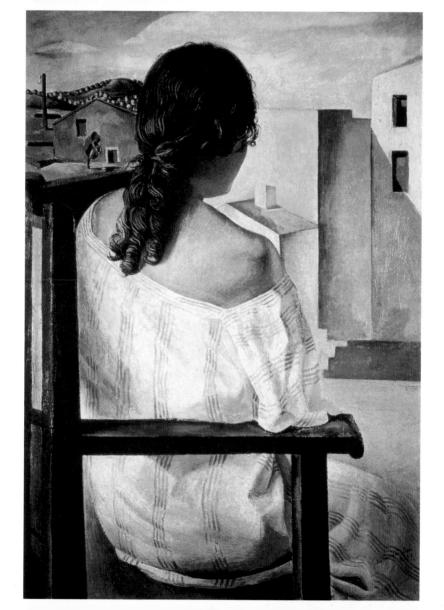

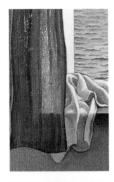

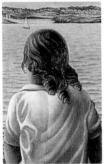

On February 6th, 1921, Felipa Doménech died. Dalí's father promptly married his deceased wife's sister, Catalin, who had already been living in his household for the last eleven years.

For Dalí, the death of his mother was "the worst blow of my whole life. I worshipped her; for me she was unique. [...] Weeping and with clenched teeth I swore that with all the power of the holy light which one day would circle my glorious name I would rescue my mother from death and from fate."

Figure at a Window

1925 oil on canvas, 103 x 75 cm Reina Sofia National Museum, Madrid

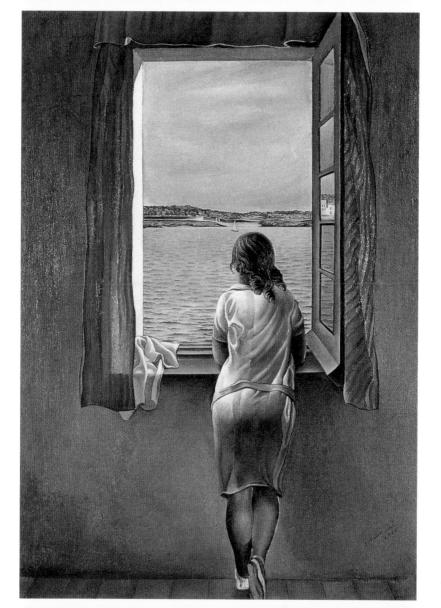

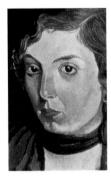

The sixteen-year-old planned his fame in detail: first he wanted to go to the vocational school of art, sculpture, and graphics in Madrid for three years, win a prize, and then continue his studies in Italy. Before departing for Madrid after having successfully completed his high school diploma, Dalí presented eight paintings at a group exhibition held by the Catalan student union in Barcelona's Dalmau gallery.

Portrait of Maria Carbona

1925 oil on panel, 52.6 x 39.2 cm Museum of Fine Arts, Montréal

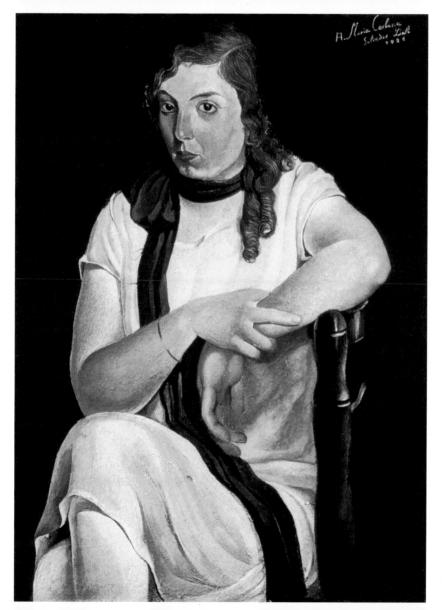

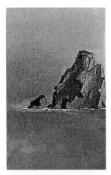

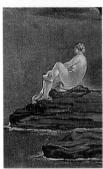

In the local press the young painter was confirmed as having extraordinary talent: "Dalí is on the road to great success."

In the autumn of 1922, accompanied by his father and his sister Ana Maria, the eighteen-year-old traveled to the entrance examination at the art school in Madrid. For over six days, the applicants had to prepare a drawing of a classical sculpture.

Penya-Segats (Woman on the Rocks)

1926 oil on olive panel, 26 x 40 cm private collection

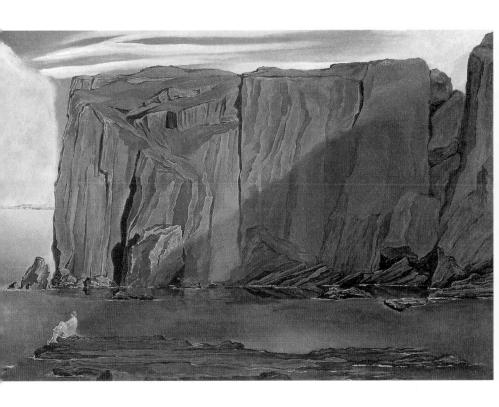

Dalí's model was a cast of Bacchus after Jacopo Sansovino. Dalí moved into a room at the "Residencia de Estudiantes", a student residential and cultural centre based on the Oxford and Cambridge model. At the beginning of the twenties a group of Spain's literary and artistic offspring lived there; amongst others, Luis Buñuel, Federico Garcia Lorca, Pedro Garfias, Eugenio Montes, and Pepin Bello.

Figure on the Rocks (Sleeping Woman)

1926 oil on plywood, 27 x 41 cm Salvador Dalí Museum, St Petersburg (Florida)

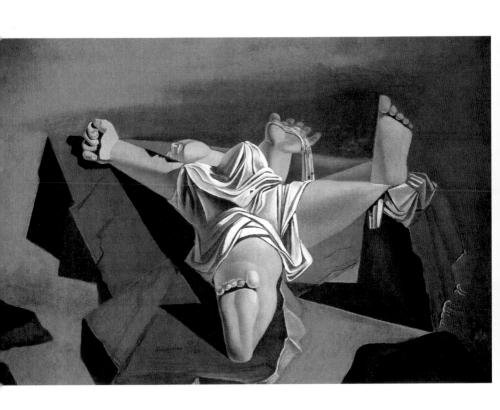

Dalí kept to himself and cultivated his role as a loner: he let his hair grow long, and dressed himself in short trousers, a long cape and a big, black felt hat. In the morning he attended his courses at the academy, and in the afternoon and evening he worked in his room. The young student did not hold many of his teachers at the academy in very high esteem; for him they were too modern. "I had expected barriers, sternness, and science.

The Girl of Ampurdán

1926 oil on plywood, 51 x 40 cm Salvador Dalí Museum, St Petersburg (Florida)

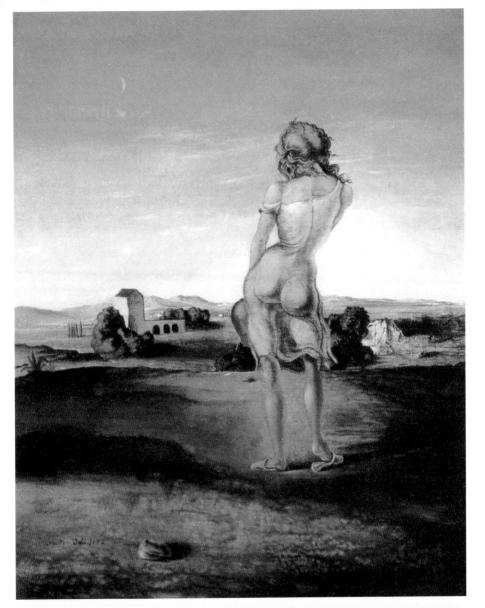

Instead I was offered freedom, laziness, new approaches!" At the same time Dalí criticized the professors for their inability to let go of French Impressionism, and their lack of attention to the newer developments in art, such as Cubism. In his private studies, Dalí read the writings of Georges Braque and bought reproductions of his pictures. He attempted to apply the new teachings on form to canvas.

Girl from the Back

1926

oil on panel, 32 x 27 cm Salvador Dalí Museum, St Petersburg (Florida)

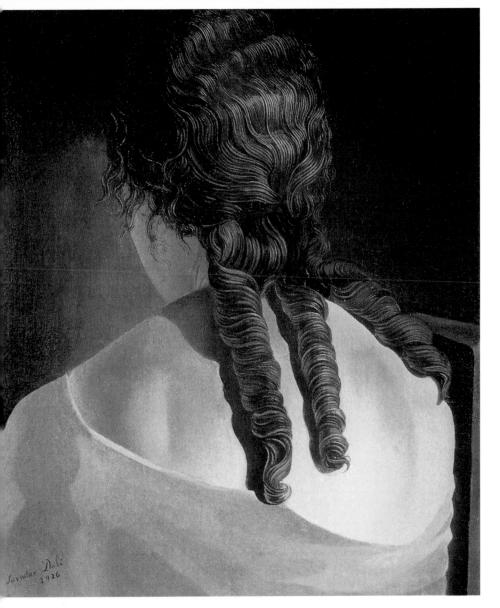

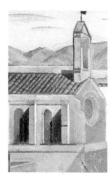

One day, one of his fellow students, Pepin Bello, discovered two Cubistic paintings in his room. Bello belonged to a literary-artistic circle, and he informed them of his findings immediately. Up to this point Dalí had been considered a reactionary eccentric. Of all people, nobody had suspected that he could be so well-informed of the newest events in Paris, the great art metropolis.

Woman at the Window at Figueras

1926

oil on canvas, 24 x 25 cm Juan Casanelles Collection, Barcelona

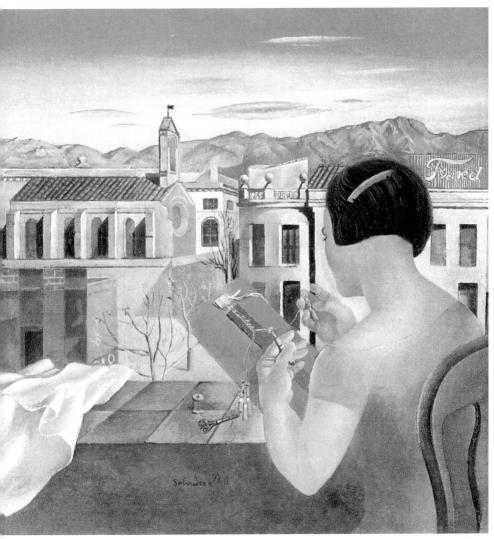

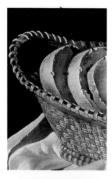

Dalí's life changed following this discovery. The interest the others showed in him suddenly transformed him: the lone wolf metamorphosed and a dandy was born.

He cut his hair and bought the most expensive suit he could find at the most elegant men's outfitter's in Madrid. After four months of living like an ascetic, Dalí began to live the life of a Bohemian.

Basket of Bread

1926 oil on panel, 31.5 x 31.5 cm Salvador Dalí Museum, St Petersburg (Florida)

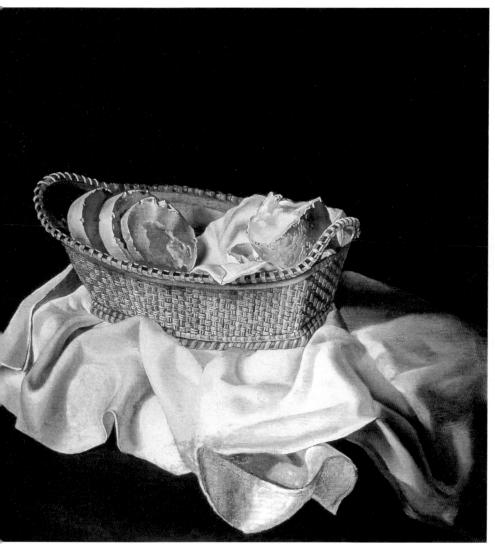

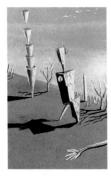

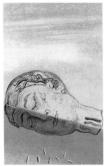

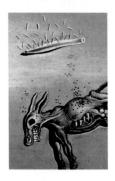

Instead of attending painting-classes he now went to restaurants and bars. In the literary-artistic circles at the Café de Pombo he met Luis Buñuel who was, later to become a film director, and the poet Federico Garcia Lorca. At the beginning of his second year of studies, Dalí was gated from the academy for twelve months. Exclusion from classes did not trouble him. He firmly believed that the professors were incapable of teaching him anything.

Study for Honey is Sweeter than Blood

1926 oil on panel, 25.1 x 32.6 cm Museum of Modern Art, New York

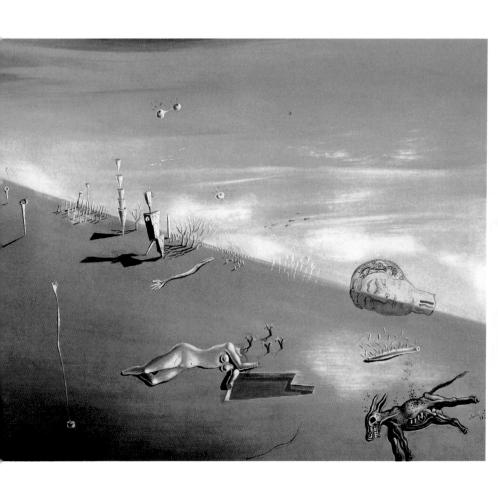

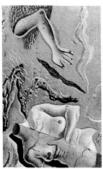

He remained in Madrid and began to study sketching nudes at the "Free Academy", which had been founded previously by the painter Julio Moisés.

At the beginning of 1924 he returned to Figueras. His sister, Ana Maria, became his preferred model. He painted rear views of her either standing or sitting at the open window. In May 1925, he took part in the First Iberian Artists' Art-Salon with ten paintings, amongst them a portrait of his friend Luis Buñuel that he had painted in 1924.

Cenicitas (Little Cinders)

1927-1928 oil on panel, 64 x 48 cm Reina Sofia National Museum, Madrid

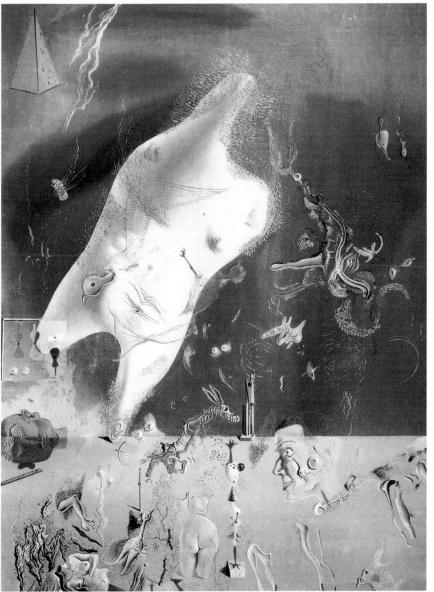

In November, the Dalmau gallery in Barcelona presented the first one man show of Dalí's paintings.

Among the most renowned visitors at the exhibition was Pablo Picasso. The forty-one-year-old was especially taken by the painting Young Girl Standing at a Window. Six months later, Dalí travelled to Paris and visited his famous countryman: "As I entered Picasso's apartment in the rue de la Boétie, I was so deeply moved and full of respect, it was as if I was at an audience with the Pope. [...]

Sun, Four Fisherwomen of Cadaqués

1928

oil on canvas, 147 x 196 cm Reina Sofia National Museum, Madrid

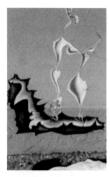

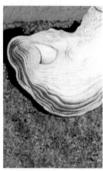

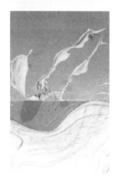

We went up one floor, where Picasso showed me numerous pictures of his own for two hours. [...] Before showing me each new canvas he threw me a look of such vivaciousness and intelligence that I began to tremble." Dalí's high regard for Picasso did not last long. Later he was to claim that just one of his own paintings was a thousand times better than the whole of Picasso's work altogether. Shortly after his return from Paris, the final examinations took place at the art school.

Bather

1928

oil, sand and gravel collage on panel, 52 x 71.7 cm Salvador Dalí Museum, St Petersburg (Florida)

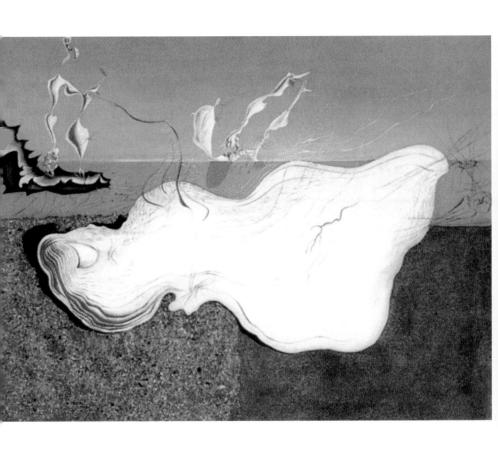

Dalí denounced the examination commission as not being qualified to assess him. He was, once more, banished from the academy and returned to Figueras. Dalí and the poet Federico Garcia Lorca had met in 1923 in Madrid but their close friendship only developed in 1925 during the Easter holidays when they travelled to Figueras and Cadaqués together. At Dalí's home Garcia Lorca organised two readings from his first drama, Mariana Pineda.

The Wounded Bird

1928

oil and sand on cardboard, 55 x 65.5 cm Mizne-Blumental Collection, Monte Carlo

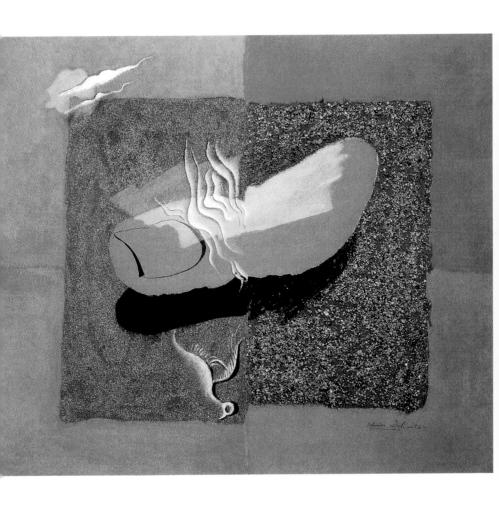

After his departure, a lively correspondence developed between Garcia Lorca and Dalí and also with Ana Maria. Garcia Lorca wrote to her using tender words.

Later, Dalí claimed more than once that the poet's love had been directed at him alone: "He was a known homosexual and madly in love with me. He tried to have me twice." But actually, Dalí's letters to Garcia Lorca take on another tone; they are still free of all the cynicism that will later become the trademark of the painter.

Anthropomorphic Beach

1928

oil, cork, stone, red sponge and polychrome finger carved of wood on canvas, 47.5 x 27.5 cm Salvador Dalí Museum, St Petersburg (Florida)

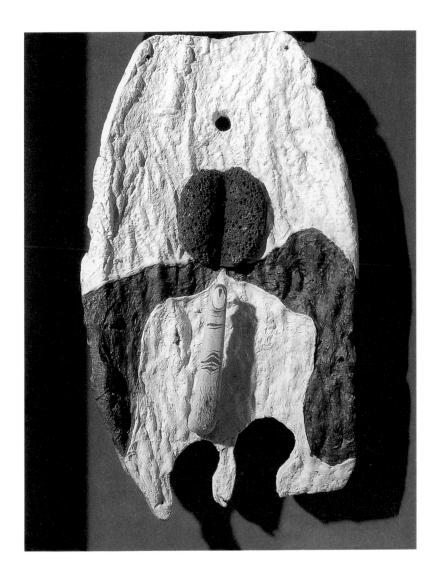

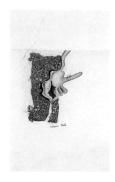

From the correspondence between Dalí and Garcia Lorca, only the letters of the painter remain almost completely preserved, while most of the others were lost in the Civil War.

In 1926, Garcia Lorca wrote *Ode to Salvador Dalí*: "But above all I sing of our mutual ideas that unite us in the dark and golden hours. Art is not the light that blinds our eyes. First it is love, or friendship or even the conflict." The portrait *Still Life* (*Invitation to Sleep*) was painted in the same year.

Unsatisfied Desires

1928

oil, sea-shells and sand on cardboard, 76 x 62 cm private collection

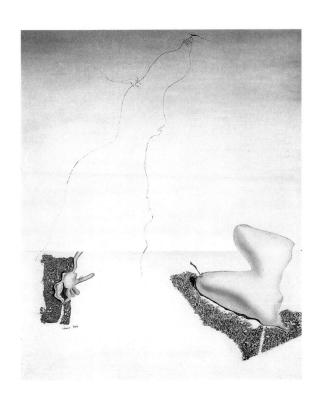

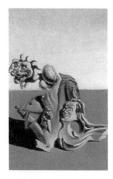

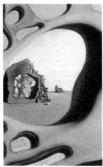

From a photo Ana Maria had taken of the sleeping poet in 1925, Dalí painted Garcia Lorca's head in the style of a Roman bust, where the plastic qualities in relief and outline are broken down into shadows and the portrayal of features. The poet and the painter do not only, in their respective work, make reference to one another – in 1926, they also began to work on a piece together: Dalí created the scenery and the costumes for the premiere of Garcia Lorca's Mariana Pineda in Barcelona.

The Enigma of Desire – My Mother, My Mother, My Mother

> 1929 oil on canvas, 110 x 150.7 cm Gallery of Modern Art, Munich

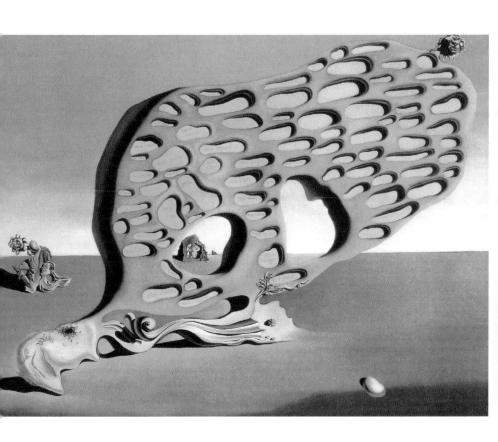

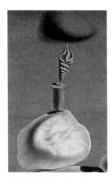

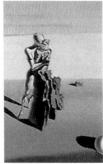

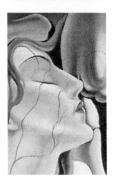

However, the date for the beginning of rehearsals at the Goya Theater was continually postponed. In the spring of 1927, Dalí impatiently wrote to Garcia Lorca "I await you every day."

In May of 1927, Garcia Lorca finally arrived in Figueras to finish the scenery with Dalí. The premiere took place on 24th June. Immediately afterwards, Garcia Lorca accompanied the Dalí family back to Cadaqués. This was the last summer that the friends spent together.

The Great Masturbator

1929

oil on canvas, 110 x 150 cm Reina Sofía National Museum, Madrid

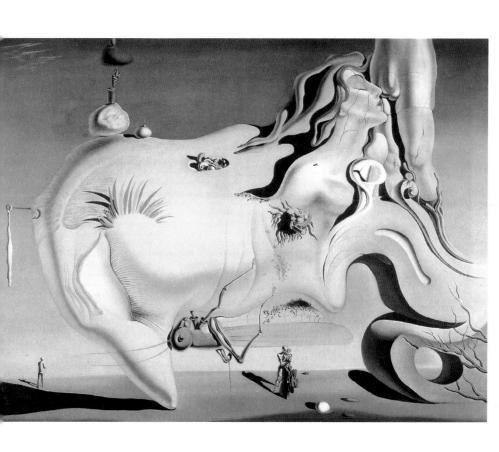

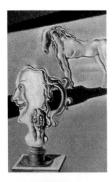

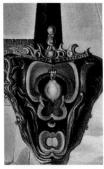

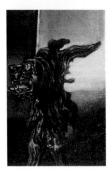

In the spring of 1928, Dalí drew the title-picture for *Gallo*, the magazine that Garcia Lorca published in Granada. However, the painter and the poet were both approaching a point in their lives where they would choose to take different directions. Dalí engaged himself in anti-art activities and joined the Surrealists; Garcia Lorca developed an ever-growing interest in folkart. In April of 1928, Garcia Lorca published his *Gypsy-Romance*. Shortly after the beginning of the Spanish Civil War, Garcia Lorca was murdered by Franco's soldiers.

The Invisible Man

1929

oil on canvas, 140 x 80 cm Reina Sofía National Museum, Madrid

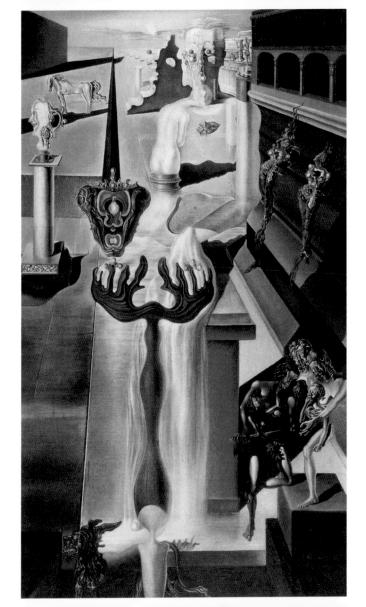

In 1966, Dalí described his reaction to the death of his young friend: "As I learnt of his death, I reacted like a bandit. Someone had brought me the newspaper, and realising that he had been executed by firing squad, I cried out: 'Olé'.[...] for Federico Garcia Lorca, I considered this to be the most beautiful death: to be mown down by the Civil War." Dalí's friendship with Buñuel preceded that with Garcia Lorca; it was only after Buñuel moved to Paris in 1925 that Dalí drew close to Lorca.

The Lugubrious Game

1929

oil and collage on cardboard, 44.4 x 30.3 cm private collection

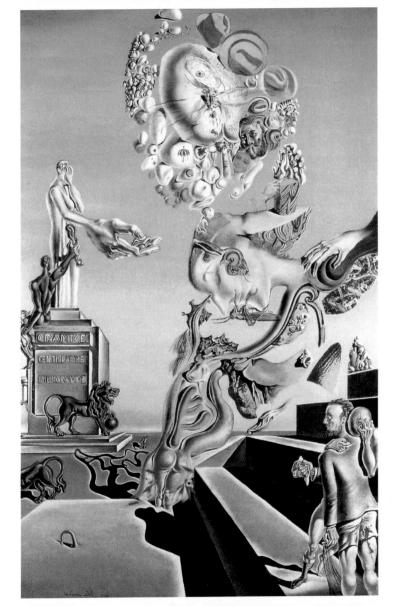

Already in Madrid, Dalí and Buñuel forged plans for a joint film project. However, this only took on real shape in the summer of 1928, when Buñuel visited Dalí in Figueras.

Six months later they met once more to finish the script, which they gave the title *Un Chien andalou* – An Andalusian Dog. Later, both authors claimed the central ideas in this joint project as their own.

Illuminated Pleasures

1929 oil and collage on hardboard, 24 x 35 cm Museum of Modern Art, New York

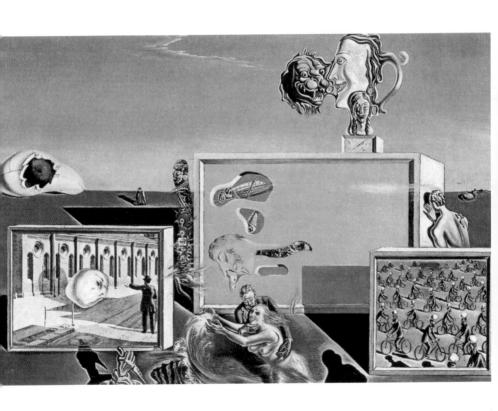

Dalí even claimed to be singularly responsible for the whole scenario: "His [Buñuel's] film idea appeared to me to be extremely average, it was of an unbelievable naive avant-garde nature. I told Buñuel that his film story did not excite the least interest. However, I, in comparison, had just written a very short script which incorporated a touch of the brilliant and which was the exact counterpart of the present film."

Profanation of the Host

1929

oil on canvas, 100 x 73 cm Salvador Dalí Museum, St Petersburg (Florida)

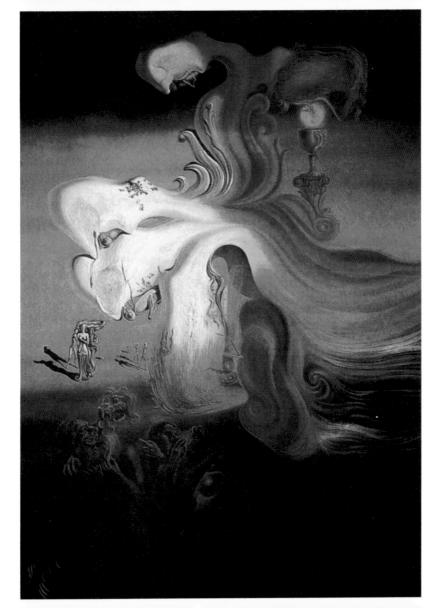

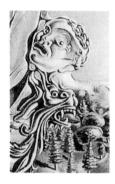

Some motifs in the film could already be found in the earlier paintings and writings of Dalí. At the end of 1926, he began working on the painting Honey is Sweeter than Blood: the body of a naked woman can be seen on a beach with hands, feet and head lying severed: the head of Garcia Lorca lying beside it with a decomposing donkey carcass. The donkey cadaver serves as a central theme in Un Chien andalou, and the scene where the woman's pupil is cut with a razor is regarded as the most well known sequence.

Portrait of Paul Éluard

1929 oil on cardboard, 33 x 25 cm formerly Gala-Salvador Dalí Collection

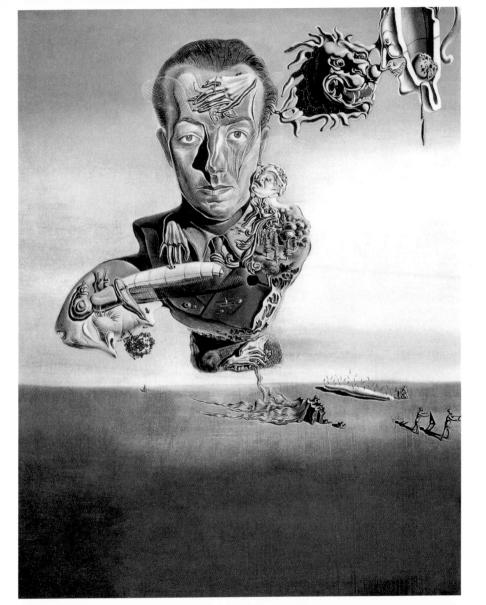

The cut eye became a central image for the Surrealists. In the spring of 1929, Dalí travelled to Paris to see the film being shot. The painter also used his stay in the French capital to look after his business affairs. There he signed a contract with the gallerist Camille Goemans and Joan Miró, who Dalí had met by way of a family friend, introduced his fellow countryman to the various Parisian circles. Dalí encountered the painter René Magritte, the sculptor Hans Arp, and the poet Paul Éluard.

The Bleeding Roses

1930 oil on canvas, 75 x 64 cm private collection, Geneva

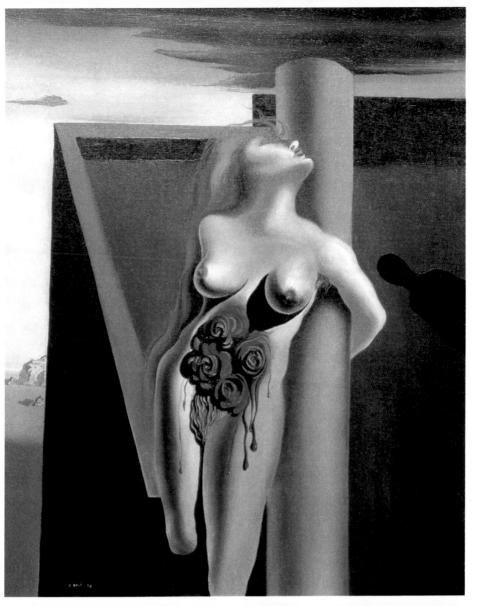

In a private screening on June 6th, 1929, Un Chien andalou was shown for the first time at the Studio des Ursulines. The audience responded to it in the way that Dalí had expected and hoped: "I wanted [the film] to shock and disrupt the normal attitudes of thought as well as the viewing attitudes and the taste that the intellectuals and snobs of the capital had for petit-bougeois entertainment; a film which was designed to return each viewer to the secret realm of their childhood"

Untitled (William Tell and Gradiva)

1931 oil on copper plate, 30.1 x 23.9 cm private collection

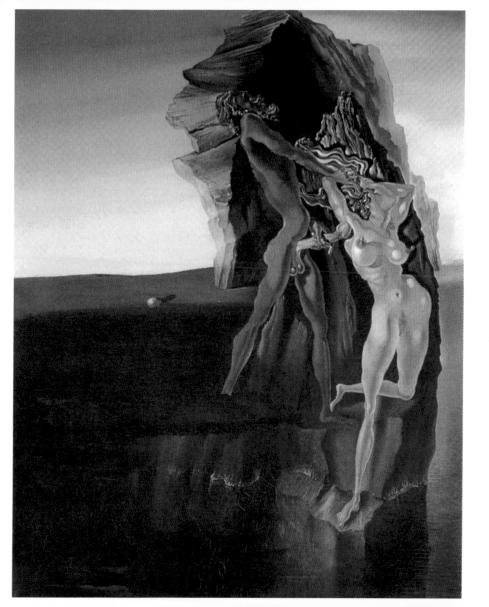

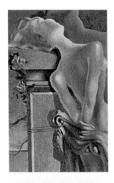

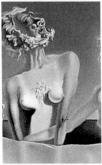

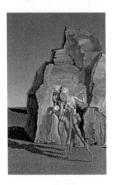

Following *Un Chien andalou*, Buñuel and Dalí became firmly placed in the spotlight of Parisian cultural life. The Viscount Charles de Noailles and his wife Marie-Laure suggested to the two Spaniards that they make another film, this time in feature-length and with sound. The noble couple were prepared to cover the production costs. The title of the project changed several times but the name, *L'âge d'or – The Golden Age*, was finally agreed upon.

The Old Age of William Tell

1931 oil on canvas, 98 x 140 cm private collection

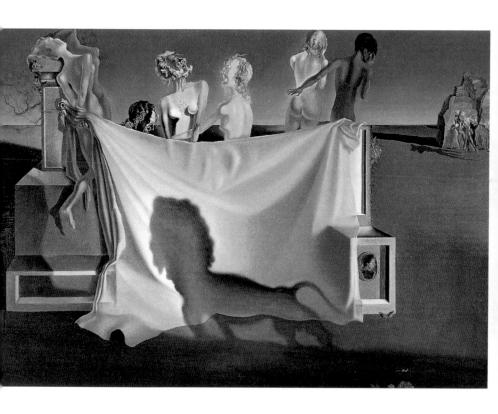

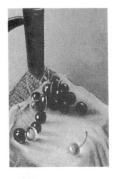

For Dalí, the period between both films is characterised by several events and changes of a decisive and radical nature. In the summer of 1929, he met Gala Éluard in Cadaqués and they fell in love with one another. At the end of November, shortly before Buñuel was due to visit Figueras, a dispute broke out between Dalí and his father. Dalí traveled to Cadaqués. A few days later, his father told him the family wished to have nothing more to do with him.

Partial Hallucination
Six apparitions of Lenin on a Grand Piano

oil on canvas, 114 x 146 cm Musée National d'Art Moderne, Paris

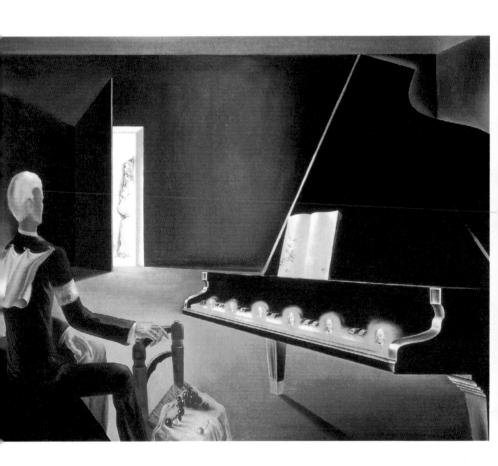

One reason for his father's anger may have been Dalí's relationship with Gala, who at this time was still married to Paul Éluard. A further cause may have been Dalí's ink-drawing *The Sacred Heart*. On it, Dalí had written: "Sometimes, I spit on the portrait of my mother for fun". At the same time in Paris, Buñuel began filming *The Golden Age*.

Dalí was not present during the production of the film and did not appear in it, but instead dedicated himself to the project in thought and reported his ideas to Buñuel by letter.

Remorse or Sunken Sphynx

1931 oil on canvas, 19.1 x 26.9 cm Kresge Museum of Art, East Lansing (Michigan)

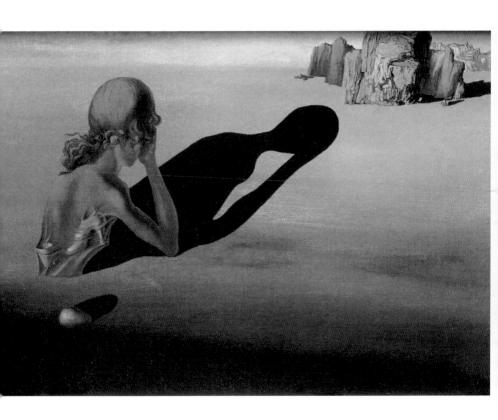

Not all his suggestions were taken up by his partner and when they were, they were significantly changed. In his autobiography, Dalí wrote: "Even in those days I was moved and intoxicated, yes even possessed by the magnificence and splendor of Catholicism. I said to Buñuel: "For this film I want plenty of archbishops, mortal remains and monstrances. I especially want archbishops, bathing between the fallen rocks at Cape Creus with their embroidered mitres.

The Persistance of Memory

1931 oil on canvas, 24 x 33 cm Museum of Modern Art, New York

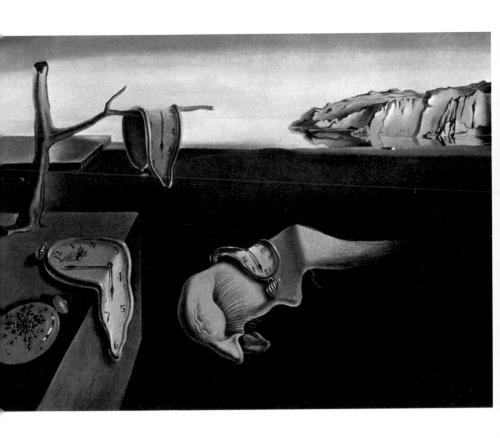

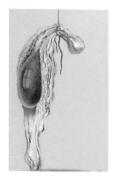

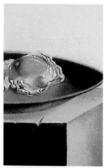

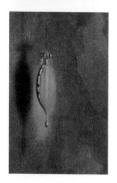

In his naïvety, and with his stubborn Aragonic manner, Buñuel managed to change all this into an example of simple anticlericalism."

At a private screening, *The Golden Age* was presented to a discerning audience on October 22nd, 1930. Among others, Gertrude Stein, Pablo Picasso, Marcel Duchamp, André Malraux and Man Ray were invited. The reaction to the film was extremely cool; most guests left the cinema directly after the end of the showing.

Fried Eggs on the Plate without the Plate

1932 oil on canvas, 60 x 42 cm Salvador Dalí Museum, St Petersburg (Florida)

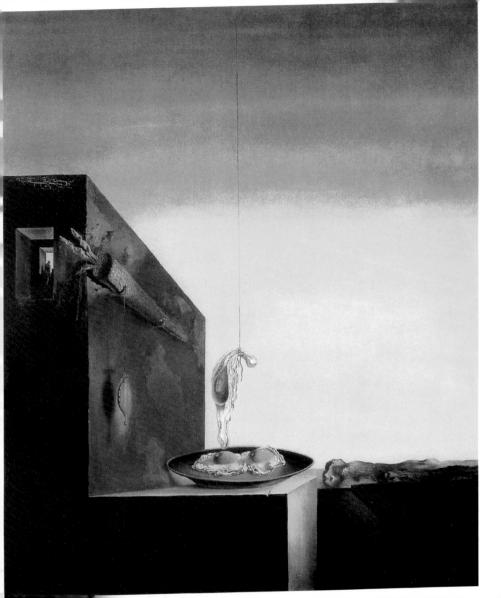

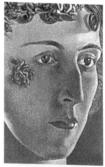

On November 28th, public screenings began at Studio 28. The Parisian Surrealists took part in the event. On December 3rd, the cinema was attacked by members of the Action Française, a right-wing and antisemitic association.

Apparently, the attack was not only directed against the film but also against its Jewish producer, Marie-Laure de Noailles. A week after the raid – during which most of the exhibited Surrealist paintings had been damaged – *The Golden Age* was prohibited in France.

Portrait of the Vicomtesse Marie-Laure de Noailles

1932 oil on panel, 27 x 33 cm private collection

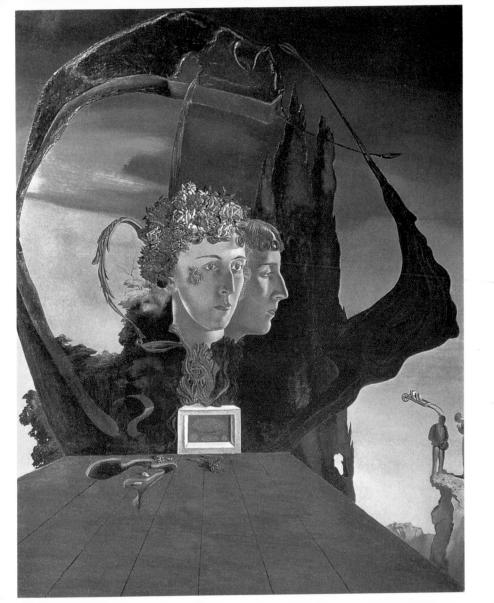

The film could not be shown for fifty years. Out of solidarity to Buñuel but not out of conviction, Dalí defended the film: "I accepted responsibility for the sacrilegious scandal, although I did not have any ambition in that direction." The friendship had however hit rocky ground. The final break came in 1934. Dalí had seen a new version of *Un Chien andalou* and had noticed that his name was no longer mentioned.

Meditation on the Harp

1932-1934 oil on canvas, 67 x 47 cm Salvador Dalí Museum, St Petersburg (Florida)

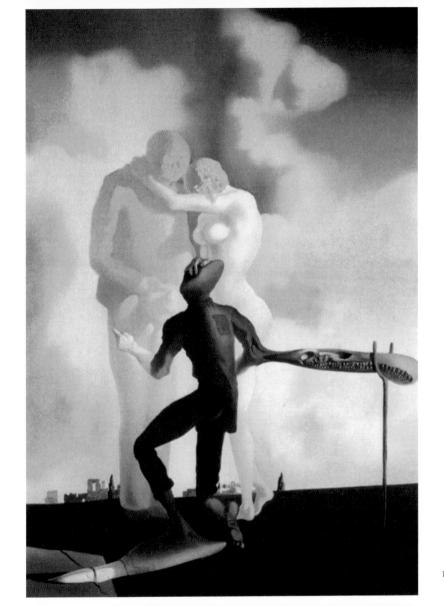

In Barcelona at the same time, *The Golden Age* was being announced as a "Film from Buñuel, in cooperation with Dalí" and not as a work of equal parts between Buñuel and Dalí. The director rejected his friend's claim. Over the course of the following years, in various interviews, they both never tired of making repeated reference to the role that each played in the authorship of the piece.

Geological Destiny

1933 oil on panel, 21 x 16 cm private collection

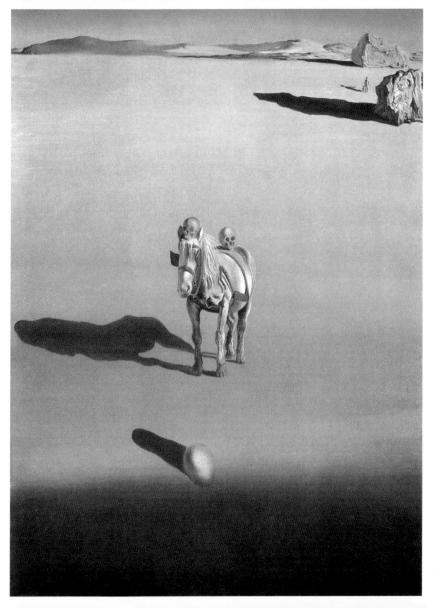

In the summer of 1929, the gallerist Camille Goemans visited Dalí in Cadaqués with René Magritte, Luis Buñuel and Paul Éluard. Éluard was accompanied by his wife Gala, and Dalí instantly fell in love. Éluard had affairs with other women and also wished that his own wife would live out her passions with other men. Between 1921 and 1924, the painter Max Ernst lived with the couple, and was at this time also Gala's lover. Many Surrealists paid court to the beautiful Mrs Éluard.

The Architectonic Angelus of Millet

1933

oil on canvas, 73 x 61 cm Reina Sofía National Museum, Madrid

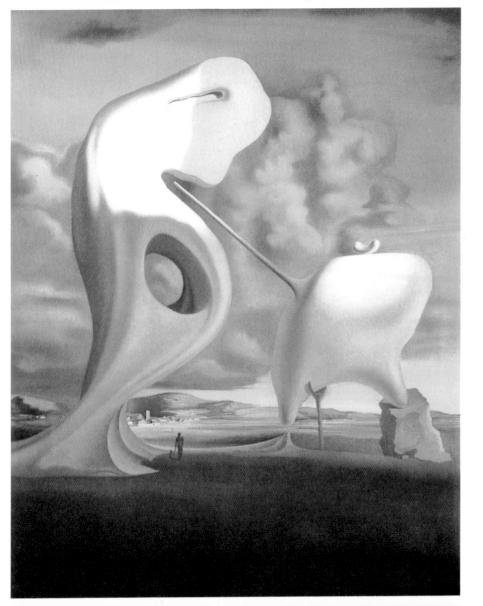

André Breton called her "the eternal woman". As Gala fell in love with Dalí in 1929, Éluard considered it just a brief love affair. He was deceived: Gala separated from him. She remained at Dalí's side until her death in 1982, marrying him at a church wedding in 1956, four years after Éluard's death. Dalí continually stressed that he would never have become the Dalí that he was without this woman at his side.

The Enigma of William Tell

1933 oil on canvas, 201.5 x 346 cm Museum of Modern Art, Stockholm

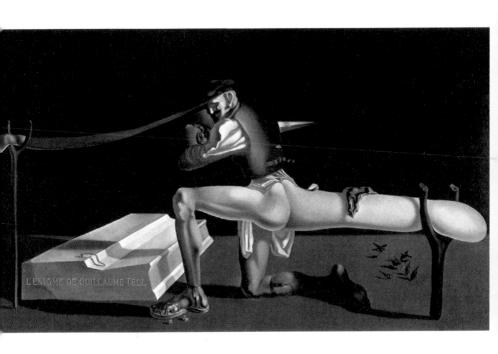

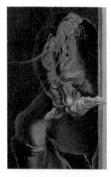

For him she was muse, model, and manager all in one. She organized Dalí's business affairs because, as he confessed, he let everybody cheat him while Gala always saw through their plans. He honoured her importance for his artistic work by signing many of his paintings with "Gala Salvador Dalí". Furthermore, Gala freed him of his impotence complex, something that had paralysed him since his early youth.

Gala and the Angelus of Millet Preceding the Imminent Arrival of the Conical Anamorphoses

> 1933 oil on panel, 24 x 18.8 cm National Gallery of Canada, Ottawa

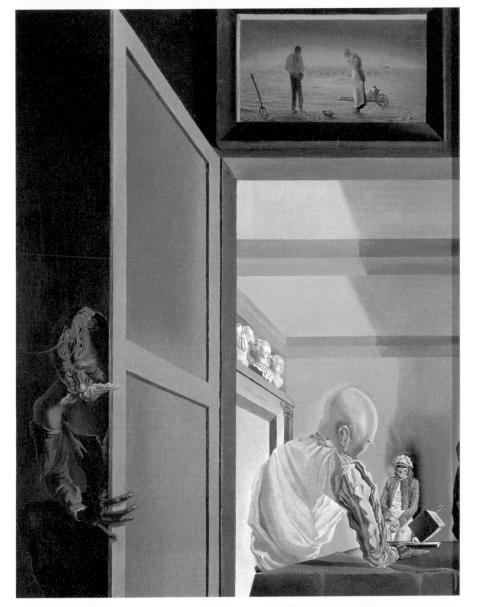

On the one hand, Dalí traced his fear of sexuality back to his father, who had often elaborated on the dangers of venereal disease to him as a child, and, on the other, to his reading of books that portrayed sadomasochistic games, which he wrongly understood to be depictions of the real act of love: "At that time my libido degenerated into such a state of downright erotic idiocy as a result of this impotence-complex [...]

Portrait of Gala with Two Lamb Chops Balanced on Her Shoulder

1933

oil on olive panel, 6 x 8 cm Gala-Salvador Dalí Foundation, Figueras

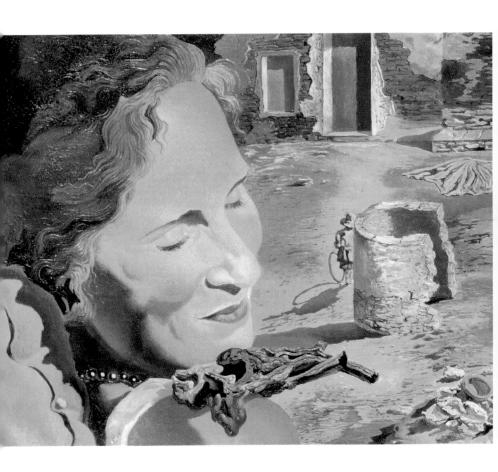

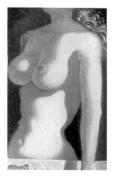

I dressed myself as a king and masturbated and had I not found Gala, who helped me discover, so to speak, normal love, then it would have taken no more than two years for all my hallucinations to over-step the measure of paranoia to such an extent that they would have become psychopathological." A painting that Dalí began in the autumn of 1929 carries the title *The Great Masturbator*.

Masochist Instrument

1933-1934 oil on canvas, 62 x 47 cm private collection

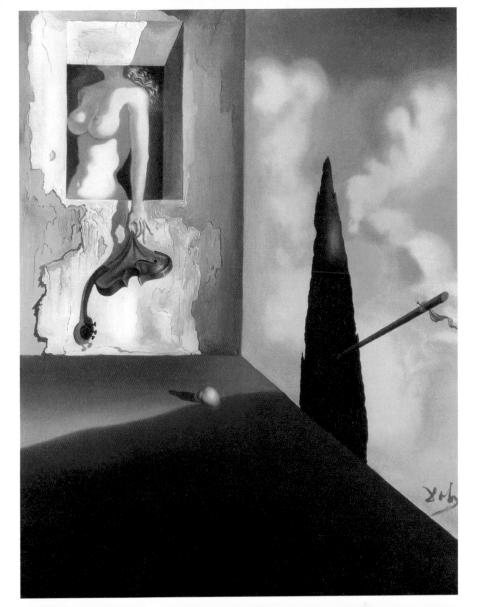

Several other works painted in this year also concern themselves with the head of the "Masturbator". In *Puzzle of Desire*, a honeycomb structure grows out of it and in its various chambers "ma mère" – "my mother" – is written. It also forms the central focus in *The Dark Game* and *Inspired Pleasures*. The four paintings were shown at Dalí's first single exhibition in Paris, at the Goemans gallery at the end of November of 1929.

Atavism at Twilight

1933-1934 oil on panel, 14 x 18 cm Kunstmuseum, Bern

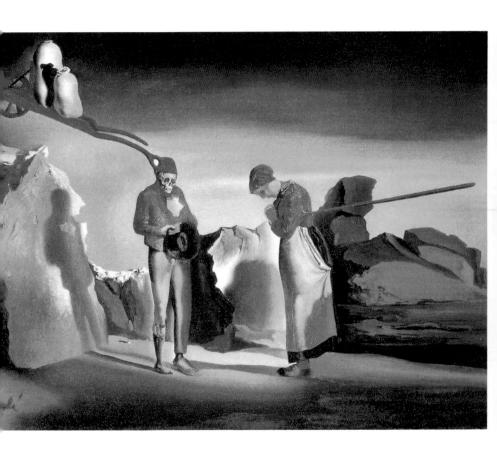

The Dark Game was bought by the Viscount de Noailles, and, of all the paintings of this period, won the greatest admiration. Dalí was celebrated by the Surrealists as being one of their own, but not without reservations. In the song of praise André Breton sung about Dalí, soft tones of misgiving can be heard. The question regarding faeces became Dalí's point of test for the Surrealists: "I possessed the ideal method of and potential for communication.

The Spectre of Sex Appeal

1934 oil on panel, 18 x 14 cm Gala-Salvador Dalí Foundation, Figueras

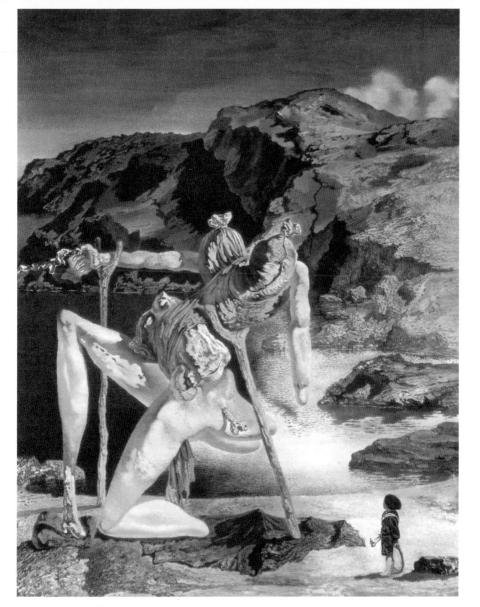

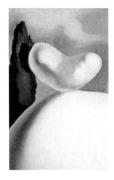

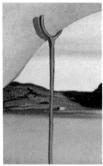

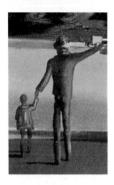

Very soon however, Breton became shocked by the evidence of so many obscene elements. He wanted neither excrement nor Madonna images. It defeats the very reason for having pure automatism if a system of control is introduced, for these images of excrement came to me in a direct, biological way."

From the very beginning, Dalí took on the position of outsider in the Parisian Surrealist scene.

Vertigo Atavism after the Rain

1934 oil on canvas, 65 x 54 cm Perls Galleries, New York

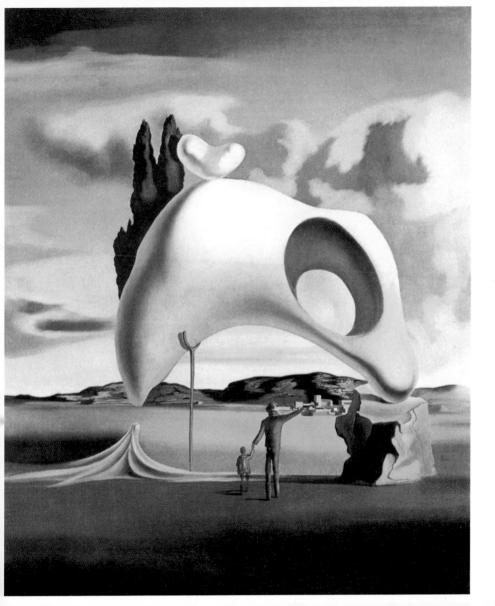

He did not just laugh about Breton's censored automatism, he also remained distant with regard to the political commitment of the group. Nevertheless, for several years, the Surrealists celebrated him as their most important representative. Dalí had, in the judgment of Breton, elevated the Surrealist mind to the point of radiance like no other before him.

The Knight of Death

1934 oil on canvas, 65.5 x 50 cm G.E.D Nahmad Collection, Geneva

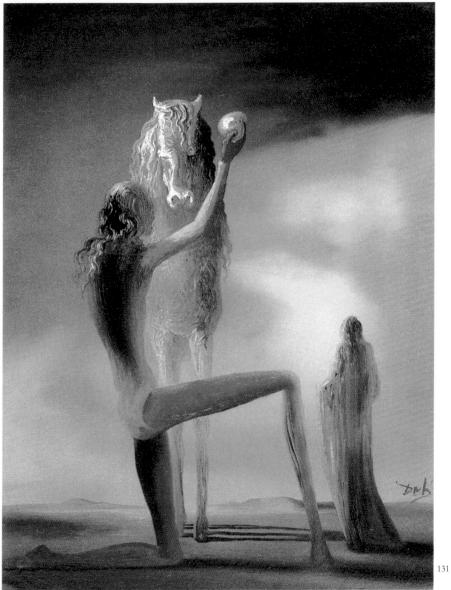

In addition to the apparently useless Surrealist objects he used to make, Dalí also invented a series of "practical" objects such as furniture made out of Bakelite, which was supposed to adapt itself to the shape of the buyer's body, or even water-trousers as a substitute for the bathtub. Dalí hoped to be able to earn money with his original ideas, for at this time his pictures were selling badly.

Surrealist Poster

1934

oil on chromolithographic advertising poster with key, 69 x 46 cm Salvador Dalí Museum, St Petersburg (Florida)

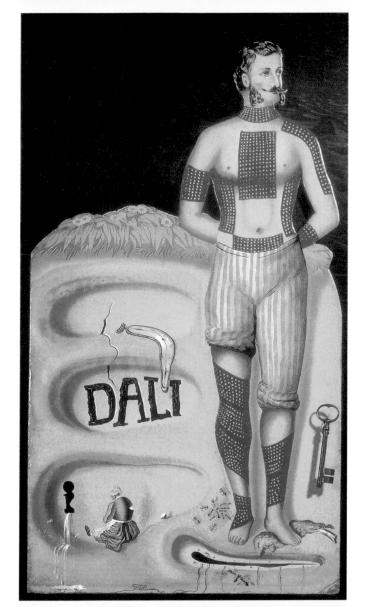

However, it was just as difficult to convince anybody to manufacture his inventions. Despite their permanent money troubles, Dalí always ensured that he and Gala did not have to live the life of Bohemians with their dirty sheets and continual fear that the electricity would be cut off. While living very economically within their four walls, outside the home they demonstrated that all was well by continually giving good tips.

The Weaning of Furniture-Nutrition

1934 oil on panel, 18 x 24 cm Salvador Dalí Museum, St Petersburg (Florida)

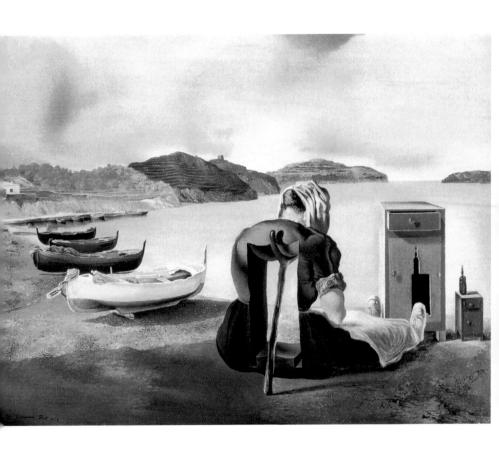

Dalí's financial situation began to improve in 1933, when a group of collectors guaranteed him the frequent purchase of his pictures. Due to his eccentric ideas, Dalí acquired a growing reputation in Paris, subsequently opening the doors to many social events: "I became indispensable at all these ultrasnobish receptions where my cane kept the beat at many successful evenings.

Mae West's Face which May Be Used as a Surrealist Appartment

1934-1935 gouache on newspaper, 31 x 17 cm Art Institute, Chicago

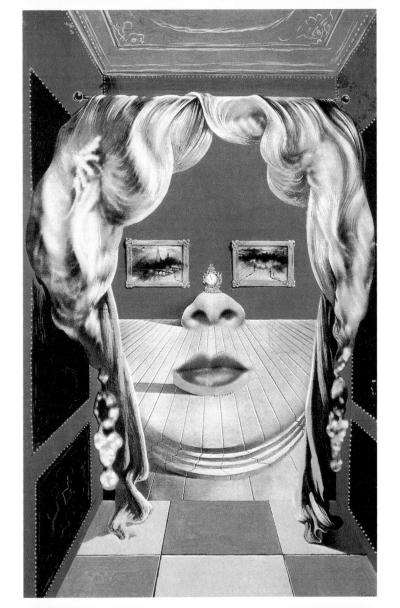

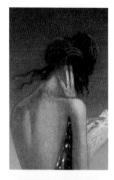

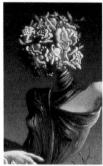

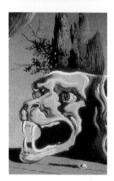

[...] I invented artificial finger-nails made out of little mirrors, which reflected the highlights of the eyes; [...] one day I appeared with a transparent dressmakers-doll, in which red fish swam around.

Every appearance was an event filled with tension." Due to Dalí's political opinions, more than once disputes broke out amongst the farreaching, Left-oriented Surrealist group.

Woman with a Head of Roses

1935 oil on panel, 35 x 27 cm Kunsthaus Zürich, Zurich

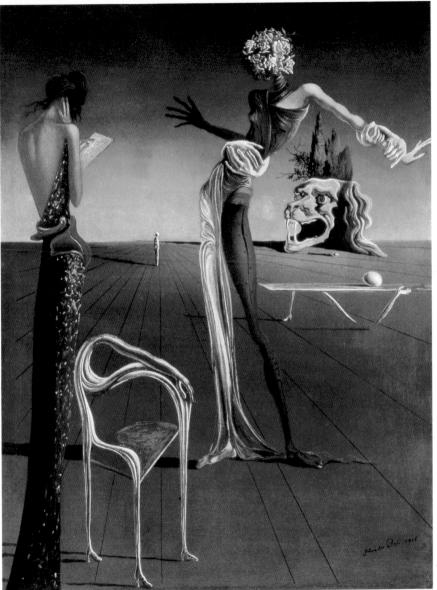

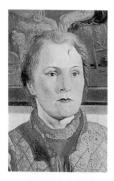

In 1933, he criticized the foreign policies of the Soviet Union and professed to be fascinated by Hitler: When Dalí exhibited his painting *The Riddle of William Tell* in the Salon of the Indépendants at the beginning of 1934, it came to a head: the picture was understood as ridiculing Lenin. Breton called the Surrealists together for a meeting in order to expel Dalí, "who has demonstrated his guilt several times via counter-revolutionary actions designed to glorify the fascism of Hitler".

The Angelus of Gala

1935 oil on panel, 32 x 26 cm Museum of Modern Art, New York

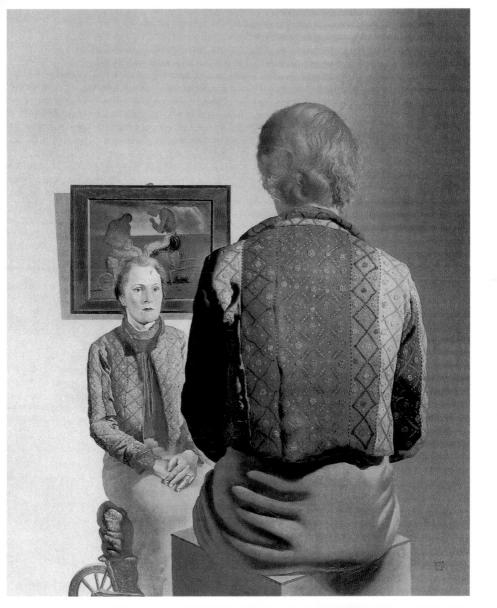

Dalí appeared at this session on February 5th, 1934, with a thermometer stuck in his mouth, claiming that he had influenza. While he spoke, he kept the thermometer between his lips, and from time to time, read off the temperature. He defended himself against Breton's accusations by stating that the dream of the great language of Surrealism could not be censored by or through logic, morals, or fear.

The Horseman of Death

1935 oil on canvas, 54 x 64 cm André-François Petit Collection, Paris

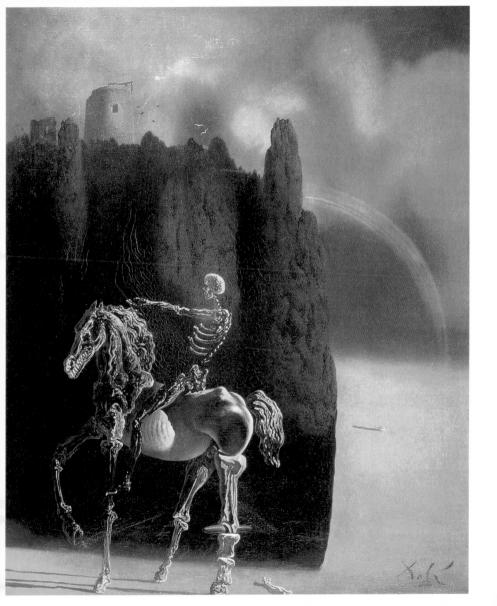

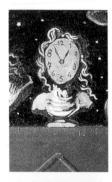

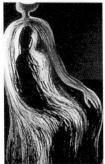

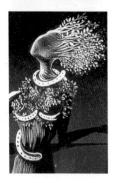

"I closed with the words: Therefore, André Breton, if I dream tonight that we make love to one another, tomorrow morning I will paint our most beautiful positions in intercourse with the greatest wealth of detail.' Breton, mortified, his pipe clamped between his teeth, growled: 'I wouldn't like to recommend you do that my friend.' He was checkmated."

Singularities

1935-1937 oil on canvas, 165 x 195 cm Estrada Museum, Barcelona

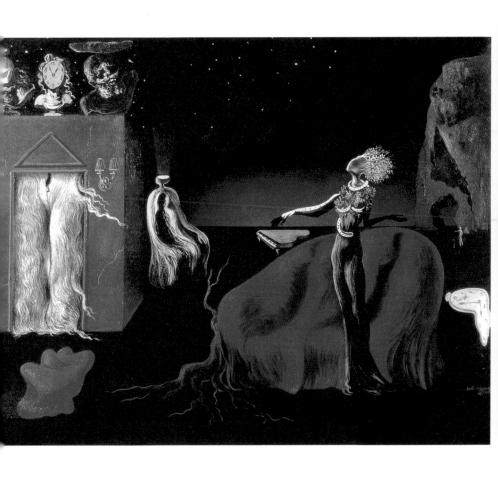

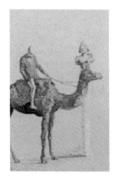

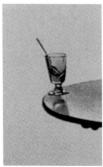

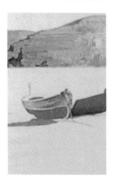

Dalí ended this grotesque interview by exposing his upper body, kneeling on the floor, and solemnly swearing that he was not an enemy of the proletariat. Even after the Paris group had expelled him Dalí still saw himself as a Surrealist, in fact, as the only Surrealist: "The difference between the Surrealists and myself exists in the fact that I am a Surrealist." Dalí developed a counterpoint to Breton's artistic procedure of automatism.

Sun Table

1936 oil on panel, 60 x 46 cm Boymans Van Beuningen Museum, Rotterdam

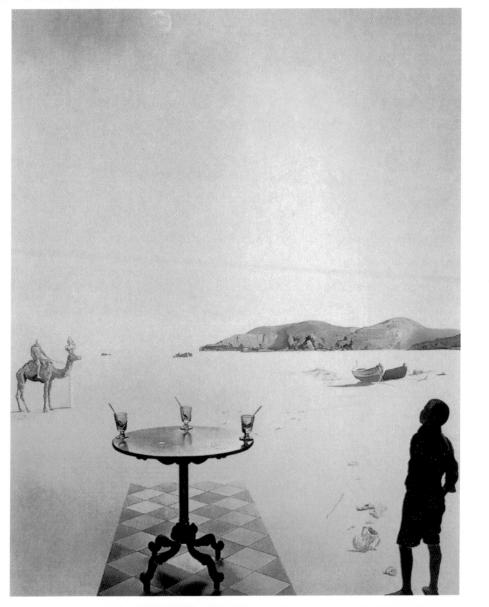

He did not orient himself towards the dream or towards insanity but found his model in the person who is paranoid because, in contrast to the maniac, this person possesses the "imperialistic power of conviction" to create other visions. In addition, the person who suffers from paranoia is capable, by means of his "systematic delusion of interpretation," of registering subtle differences and emotions.

Soft Construction with Boiled Beans – Premonition of Civil War

> 1936 oil on canvas, 100 x 99 cm Museum of Art, Philadelphia

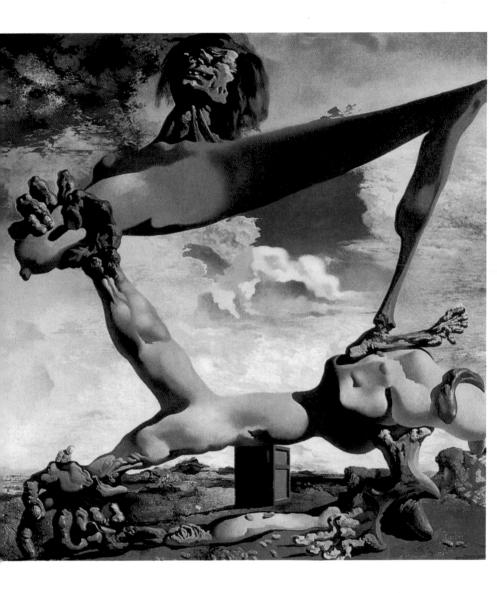

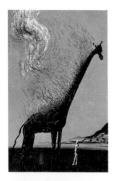

Dalí mentions in his autobiography that even as a child he had already developed the ability to recognize different pictures behind optical appearances.

In 1929, Dalí noted various ideas on his concept of the double picture. Gala organized his "confusion of unintelligible scribbles" and published it in 1930 under the title *La femme visible – The Visible Woman*.

The Burning Giraffe

1936-1937 oil on panel, 35 x 27 cm Kunstmuseum, Basle

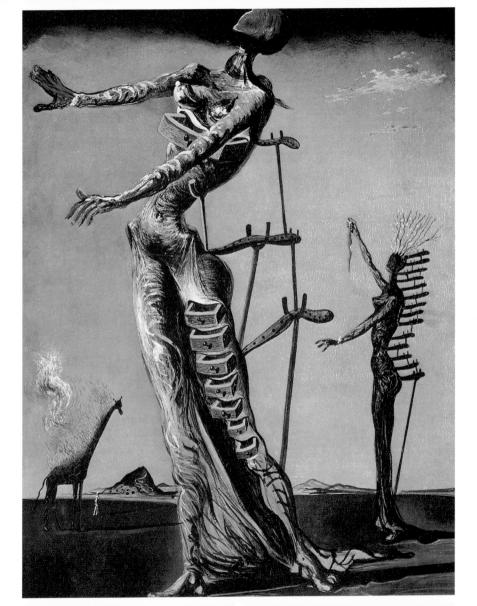

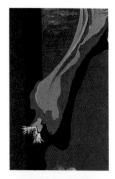

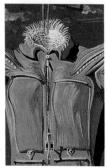

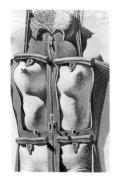

In the first essay of the collection, titled *The Donkey's Carcass*, Dalí exclaims that paranoiac activity, in contrast to hallucination, is always linked to controllable, continually recognizable materials: "By way of a clear paranoiac process, it becomes possible to receive a double image of perception: that is, the depiction of an object, that without the least physical or anatomical change is simultaneously the depiction of another wholly different object."

Night and Day Clothes of the Body

1936 gouache on paper, 30 x 40 cm private collection

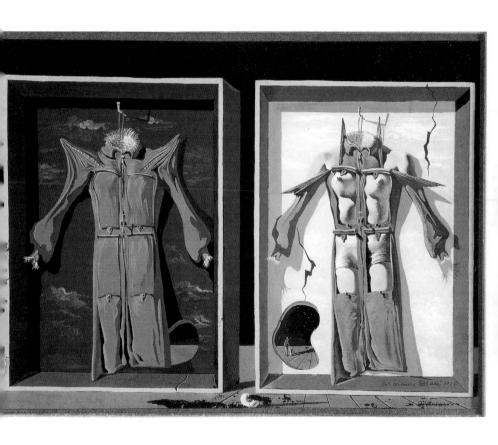

Dalí's pictures are the imprint of his "paranoiac clairvoyance". Not seldom does the process of identifying the secret hidden behind superficial appearances continue over many years. Two examples of this are the paintings Angelus, after Jean-François Millet, and The Railway Station at Perpignan. Dalí had known Millet's painting since his early childhood: "Every time time I saw the painting of this farmer and his wife, both standing motionless opposite one another, I experienced an inexplicable sensation of disquiet.

Geodesic Portrait of Gala

1936 oil on panel, 21 x 27 cm Yokohama Museum of Art, Yokohama

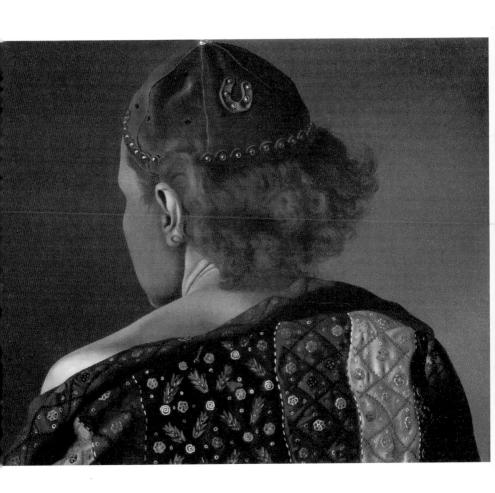

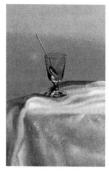

The man stands hypnotized – and destroyed – by the mother. He seems to me to take on the attitude of the son rather than the father. One could say that the hat which he holds, and said in the language of Freud, signifies sexual excitement, in order to demonstrate the shameful expression of manhood." At the beginning of the sixties, Dalí learnt that Millet had originally painted a coffin containing their dead son between the farmer and the farmer's wife, later painting over the detail, because it appeared to him to be too melodramatic.

A Couple with Their Heads Full of Clouds

1936

oil on panel, 92.5 x 69.5 cm (man) 82.5 x 62.5 cm (woman) Boymans Van Beuningen Museum, Rotterdam

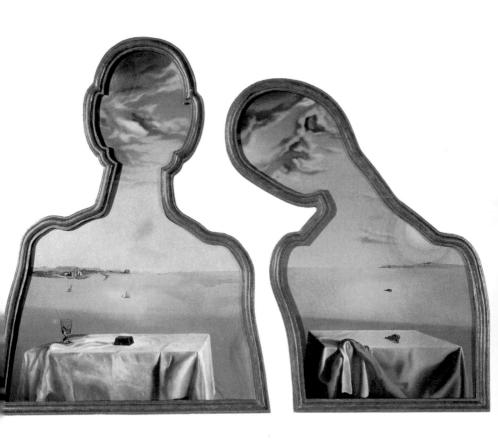

Dalí asked the Louvre to make an x-ray of the picture, and it was actually possible to see the outlines of the coffin: "Now everything has been explained! My paranoiac-critical genius had guessed the essentials of the matter." In a similar manner, Dalí found the railway station at Perpignan to be a magical place. Dalí's opinion was that the railway station is an exact model of the universe, the cosmos. He began to measure out the railway station, and organized hundreds of photographs to try and find the hidden secret on the enlarged prints.

The Anthropomorphic Cabinet

1936 oil on panel, 25.4 x 44.2 cm Kunstsammlung Nordrhein-Westfalen, Düsseldorf

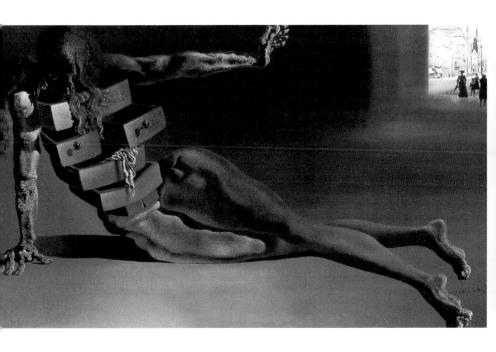

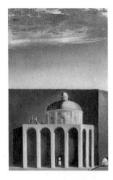

He found the explanation for his inspiration in 1966, as he learned, "that the measurements of the earth, and of the meter, had been calculated and laid down in Perpignan. A meter is not just the 40 millionth part of the Earth's meridian, it is also the formula for the specific weight of God, and this is the reason why this place appeared to me to be so outstanding. The railway station at Perpignan became transformed into a place of genuine holiness." Dalí quoted Millet's Angelus in many of his paintings.

Suburbs of Paranoiac-Critical Town: Afternoon on the Outskirts of European History

1936 46 x 66 cm Boymans Van Beuningen Museum, Rotterdam

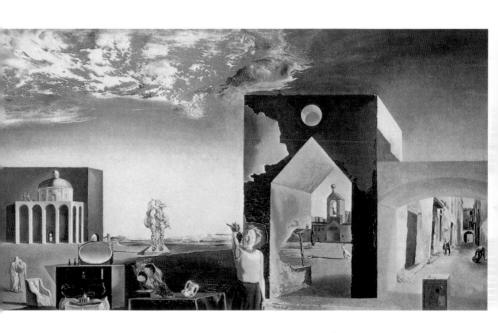

The farming couple also appeared portraying the universe in 1965 in his *Vision of the Farm at Perpignan*.

Independent of other developments, the paranoic-critical method remained the basic principle in Dalí's work. The analysis however, did not always take place over a series of years. Often discoveries in the form of spontaneous over-blending occured, as in the case of his renowned melting watches.

Cover of Minotaure no. 8

1936

ink, gouache and collage on cardboard, 33 x 26.5 cm Isidore Ducasse Fine Arts, New York

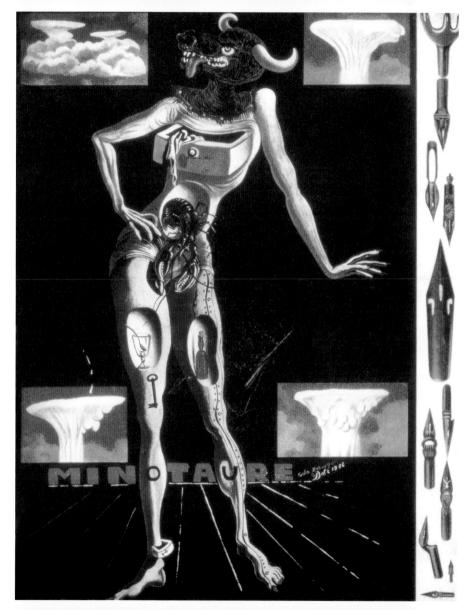

Dalí discusses the genesis of the painting, The Persistence of Memory in his autobiography: "Having concluded our dinner with a very strong Camembert and after the others had gone, I remained sitting quietly at the table for a long time considering the philosophical problem of 'Super-Softs' that the cheese had brought to my attention. I stood up, went into my atelier and turned on the light to take one last look at the picture I was presently working on, as was my habit.

Three Young Surrealist Women Holding in Their Arms the Skin of an Orchestra

1936 oil on canvas, 54 x 65 cm Salvador Dalí Museum, St Petersburg (Florida)

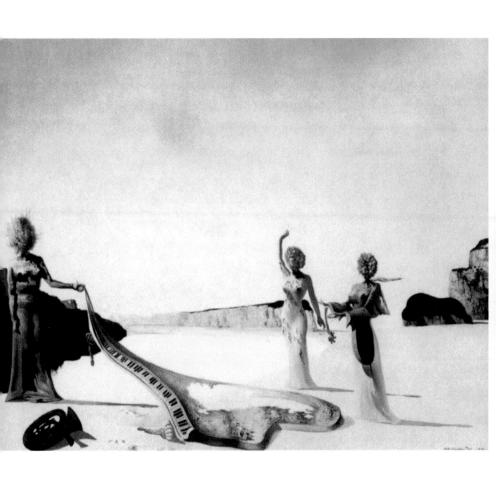

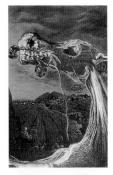

This picture depicts the landscape at Port Lligat; the cliffs lie in a transparent, melancholy dusk light and an olive-tree with severed branches devoid of leaves stands in the foreground. I knew that the atmosphere which I had been able to create with this landscape was the background for an idea that would serve to create a surprising picture but I didn't know in the slightest what it would be. I was just about to turn off the light when I suddenly 'saw' the answer. I saw two melting watches, one hanging pathetically over the branch of the olive-tree.

Debris of an Automobile Giving Birth to a Blind Horse Biting a Telephone

> 1938 oil on canvas, 54 x 65 cm Museum of Modern Art, New York

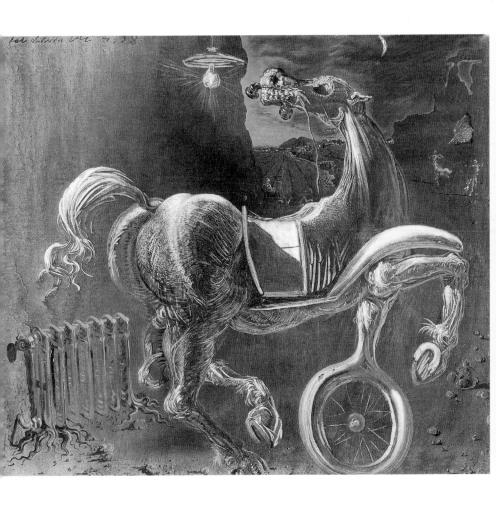

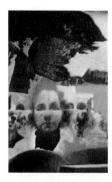

Although my headache had become so strong that I was suffering, I readied my palette impatiently and got down to work."

In November of 1934, Dalí and Gala travelled to the United States for the first time. Dalí's work had been known there since the end of the twenties. Julien Levy, who was one of the first to introduce the European Surrealists to the USA, exhibited Dalí's pictures in several group exhibitions, and in the winter of 1933, he devoted his first single exhibition to him.

Impressions of Africa

1938

oil on canvas, 91.5 x 117.5 cm Boymans Van Beuningen Museum, Rotterdam

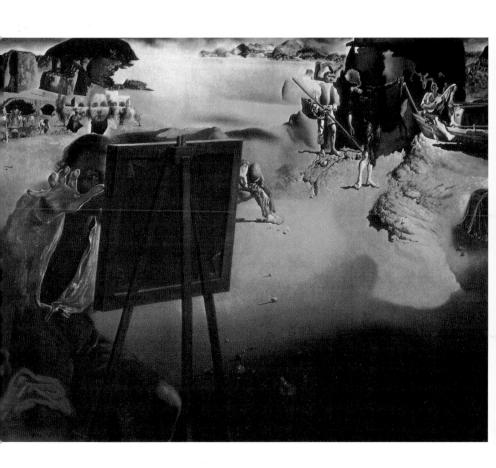

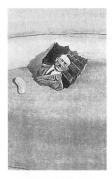

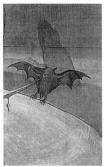

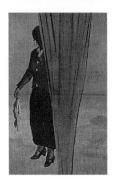

Dalí's exhibition at the Levy gallery in 1934 was criticised by some newspapers as being a "fashion show" but for the public it was an unrivalled success. The New World offered Dalí unbridled possibilities for celebrating the sensational and eccentric. Shortly before the Dalí's returned to the Old World in January 1935, Caresse Crosby organized a parting celebration at the elegant New York restaurant Coq Rouge. This "dream-ball" has gone down in history as the first Surrealist's ball.

The Enigma of Hitler

c.1939 oil on canvas, 51.2 x 79.3 cm Reina Sofía National Museum, Madrid

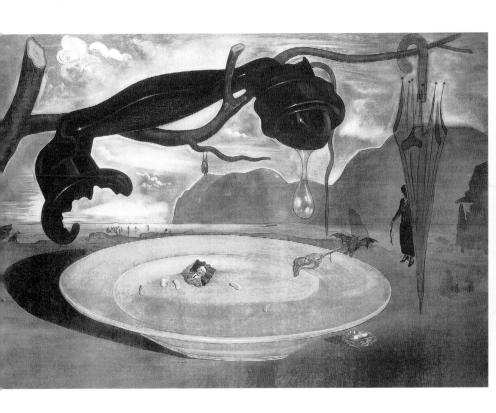

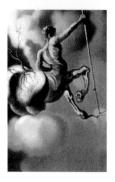

Dalí was impressed by the crazy ideas of the guests: "Society women appeared with their heads stuck in bird-cages and otherwise practically naked. [...] In the middle of the staircase a bathtub full of water had been hung, which threatened to fall down and empty its contents over the heads of the guests at any moment. And in the corner of the hall hung a butcher's hook with a whole, hollowed-out ox hanging from it, the gaping belly of which was held open with crutches, and stuffed full with half a dozen gramophones."

Honey is Sweeter than Blood

1941 oil on canvas. 49.5 x 60 cm Santa Barbara Museum of Art, Santa Barbara

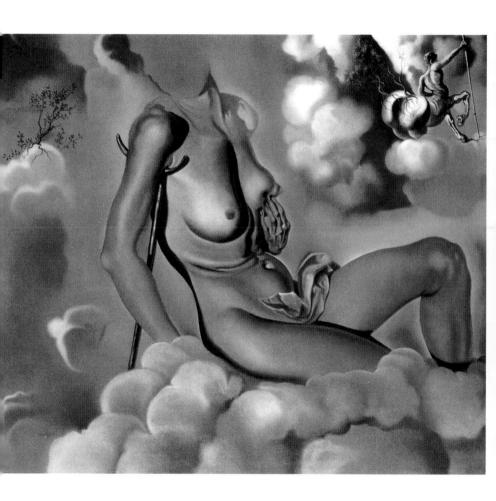

On their arrival in Paris, the atmosphere in the French capital felt oppressive for Dalí: the Surrealists were getting caught up in political conflict. He decided to escape with Gala to the isolation of Port Lligat. The peace on the Catalan coast did not last for long. In Barcelona, the first bombs were exploding – an antecedent to the Civil War. The Dalí's decided to travel.

Until 1940, they remained constantly en route. Twice in the winter of 1936/1937 and in January 1939 they traveled to the USA.

Soft Self-Portrait with Fried Bacon

1941 oil on canvas, 61.3 x 50.8 cm Gala-Salvador Dalí Foundation, Figueras

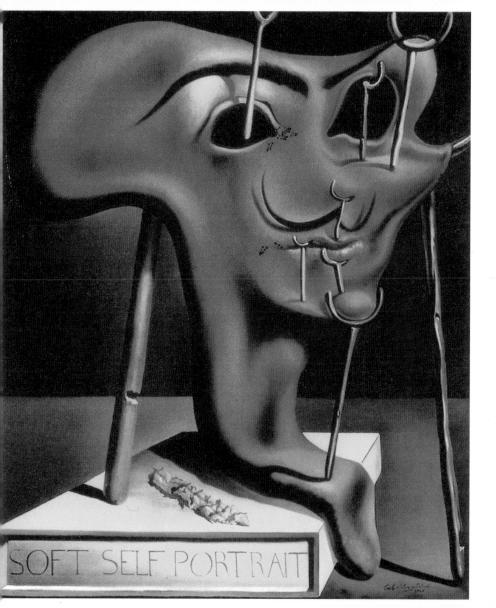

In between times they lived in Italy and the south of France. Dalí decided "decisively" that he was not a historical person. The war also failed to alter his point of view. In pictures like Soft Construction with Boiled Beans — Premonition of the Civil War, he showed his vision of the carnage. The political dimension of the state of affairs in his fatherland, however, did not interest him at all. He instead turned to studying the painting of the Renaissance.

Fighting the Minotaure

1942

pencil, Indian ink, watercolour and gouache, 58.6 x 73.8 cm Gala-Salvador Dalí Foundation, Figueras

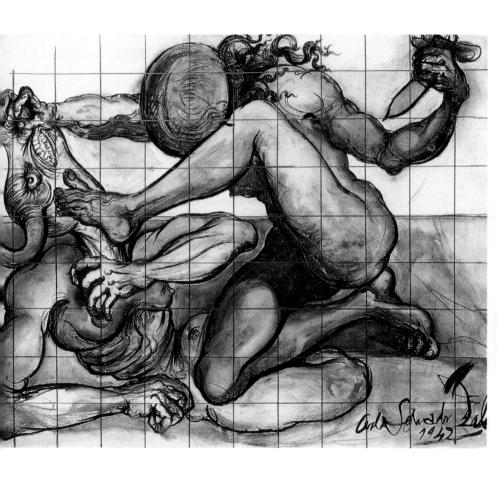

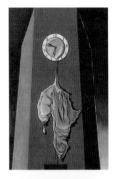

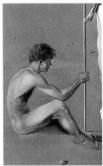

In Dalí's opinion, the history of the time was not reflected in the conversations of the Surrealists in the cafés of Montmarte, but at the Place Vendôme, in the heart of the fashion world. Dalí had befriended the fashion-designers Coco Chanel and Elsa Schiaparelli. Dalí drafted a perfume bottle in the form of a golden mussel for the latter as well as a shoehat and some clothing. These excursions into the world of design brought him into bad favour in the art world.

Poetry of America, the Cosmic Athletes

1943 oil on canvas, 116.8 x 78.7 cm Gala-Salvador Dalí Foundation, Figueras

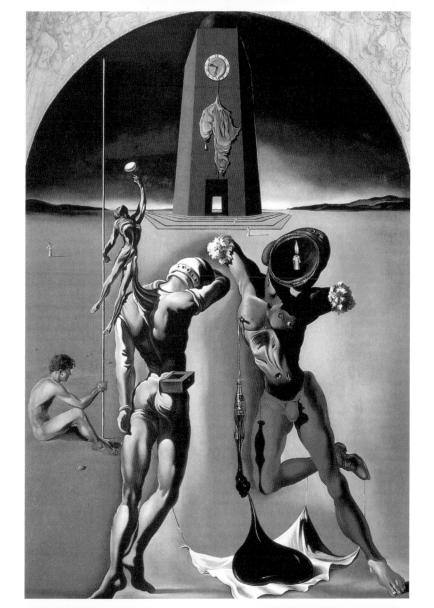

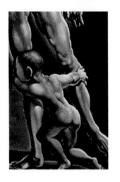

André Breton formed the anagram "Avida Dollars" – "dollar hungry" – out of the letters of the name Salvador Dalí. Dalí was in the process of achieving his goal: becoming famous not just amongst a small circle of discerning artist-friends but to a much larger audience as well. On his second trip to New York in December 1936, Time magazine devoted the title page to him. It featured a portrait that Man Ray had taken of him.

Geopolitical Child Watching the Birth of the New Man

1943 oil on canvas, 45.5 x 50 cm Gala-Salvador Dalí Foundation, Figueras

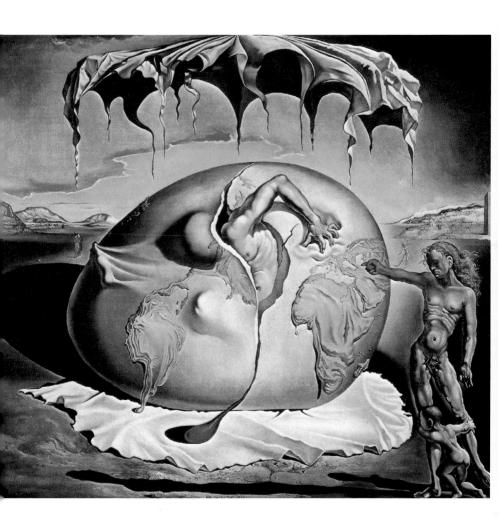

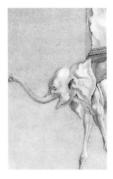

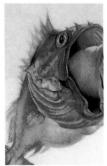

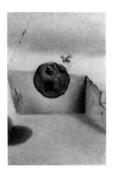

The day after the opening of his second single exhibition at the Levy gallery, all twenty-five paintings and twelve drawings were sold. Dalí was showered with offers of work. For the New York luxury department store Bonwit-Teller on Fifth Avenue, he decorated a display window: "I used a jointed-doll, with a head made out of red roses and fingernails of ermine. On a table stood a telephone that turned into a lobster; and over the chair hung my famous aphrodisiac jacket."

Dream Caused by the Flight of a Bee around a Pomegranate, One Second before Awakening

> 1944 oil on canvas, 51 x 40.5 cm Thyssen Museum, Madrid

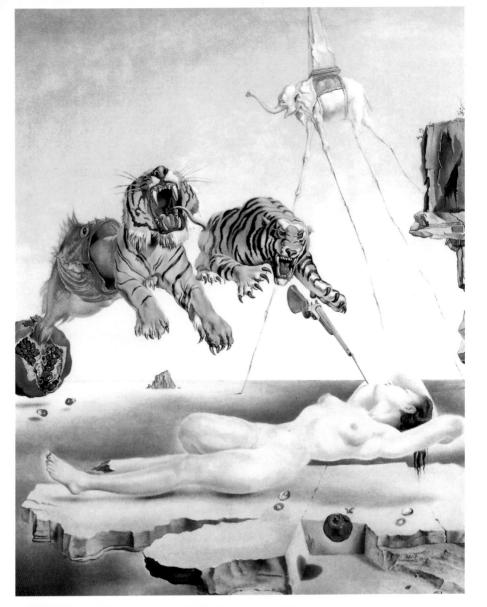

Dalí started a fashionable trend with this decoration: when he returned to New York two years later, he noticed that an array of display windows on the elegant shopping-street had been decorated à la Dalí.

In order to demonstrate the difference between the real and the imitated Surrealist decorations, he designed two further displays for Bonwit-Teller. This time, he used dusty old wax-dolls from the year 1900, which he had found in the attic at the department store.

Design for the Set of the Ballet Tristan and Isolde

1944 oil on canvas, 26.7 x 48.3 cm Gala-Salvador Dalí Foundation, Figueras

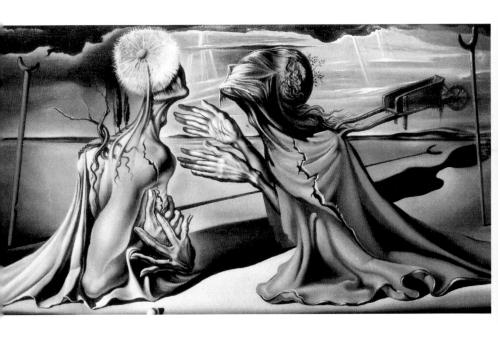

As Bonwit-Teller changed this decoration a day later – the dolls were exchanged for others, the burning bed was removed – Dalí smashed-in the display window. He spent a night in prison. In the press, he was lauded for his open fight for the "independence of American art, which all too often is threatened by the inefficiency of industrial and commercially oriented middlemen." In Europe war had begun. In their search for a place to live, the Dalí's combined the possibility of Nazi invasion "with gastronomical potential".

Study for the Backdrop of the Ballet Tristan Insane (Act II)

1944 oil on canvas, 61 x 96.5 cm Gala-Salvador Dalí Foundation, Figueras

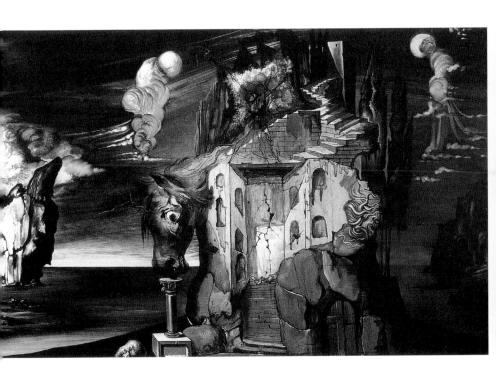

They chose Arcachon near Bordeaux and moved into a large villa built in the colonial-style. In June, however, the first bombs began to fall on Bordeaux. The Dalí's decided to escape to the USA. Dalí took a detour via Figueras. He visited his father and sister, whom he had not seen for eleven years.

The Civil War had also left scars on his family home – his sister had been tortured by the military intelligence and been driven into madness.

Design for the Ball in the Dream Sequence in "Spellbound"

1944 oil on canvas, 50.5 x 60.5 cm private collection

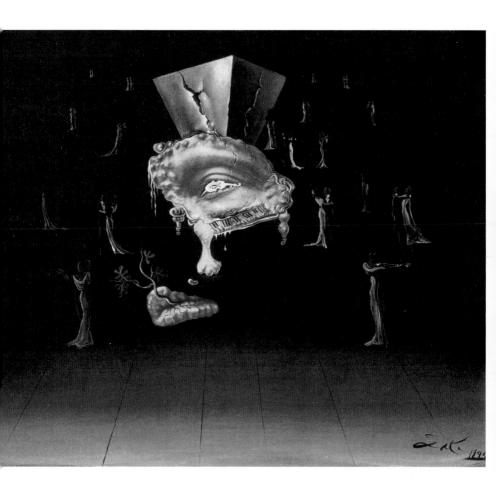

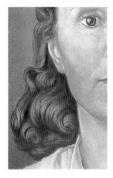

A bomb had destroyed the balcony on the house. The tiled floor in the dining room had been blackened by fire.

Nevertheless, Dalí found that in itself, "fundamentally", nothing had changed. The visit to Figueras supported Dalí's belief that the war in Europe would not bring any change. In his opinion, the old world destroyed itself, not to give birth to something new, but instead to return to the roots of tradition.

Galarina

1944-1945 oil on canvas, 64.1 x 50.2 cm Gala-Salvador Dalí Foundation, Figueras

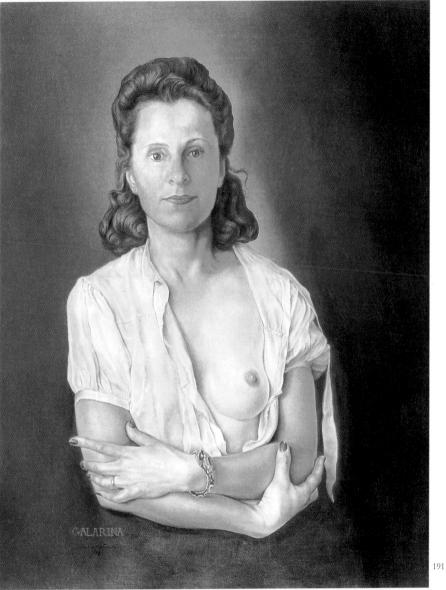

Dalí already sensed the coming renaissance and began to work on a cosmogony, on a world design, created by Dalí, the divine. He accepted his departure to the USA by reasoning that he needed a quiet place to prepare the genesis of his world design. Arriving in the USA, Dalí wrote his autobiography. It was an act of shedding his skin – he stripped off his hitherto existing life.

Dalí saw himself as a universal genius in the sense of Leonardo da Vinci.

My Wife, Nude, Contemplating her own Flesh Becoming Stairs, Three Vertebrae of a Column, Sky and Architecture

> 1945 oil on panel, 61 x 52 cm José Mugrabi Collection, New York

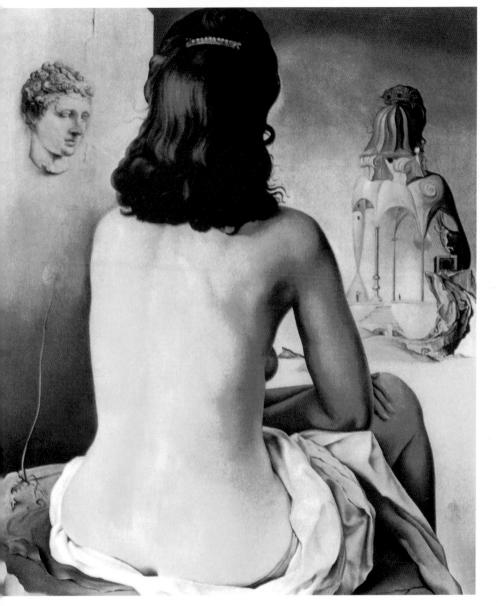

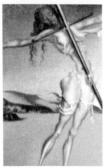

He had always worked in a variety of different disciplines besides painting: he had studied philosophy and psychoanalysis, had written scripts, had designed furniture and clothing, had created scenery and costumes for drama and opera and had choreographed a ballet. The break which Dalí decided upon at the beginning of his eight-year stay in the New World was primarly based on the decision to transform the name that he had acquired into a lucrative market

Napoleon's Nose, Transformed into a Pregnant Woman, Walking His Shadow with Melancholia Amongst Original Ruins

> oil on canvas, 51 x 65.5 cm G.E.D Nahmad Collection, Geneva

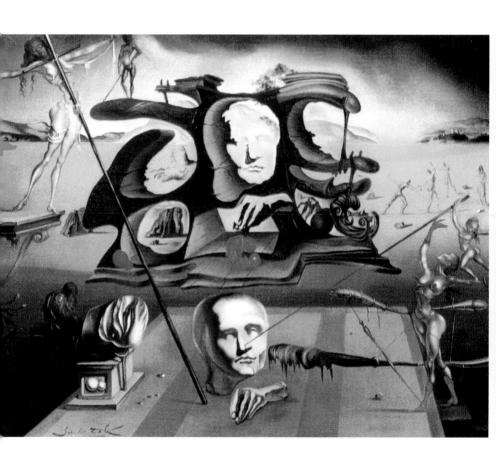

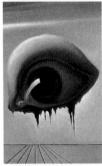

The moustache became his trademark. A decisive role here was played by the photographer Philippe Halsman. One of the first photographs by Halsman taken of the artist at the beginning of the nineteen-forties, shows Dalí in tails, in front of a skull formed out of naked women's bodies, sporting a top hat and cane. Dalí stylized himself as an art object.

The Eye – Design for "Spellbound"

1945 oil on panel dimensions unknown, private collection

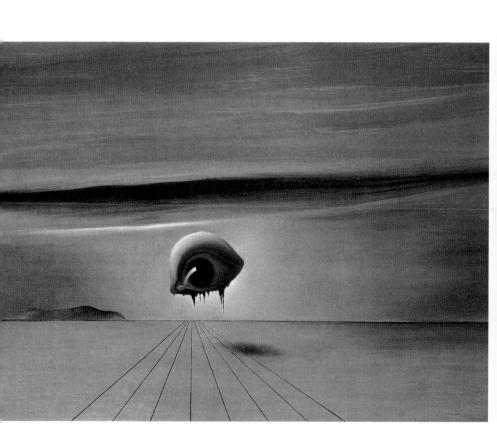

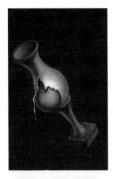

In depicting himself, the painter was continually and thoroughly ironic: for one of the photos he transforms his moustache into a dollar-sign – an allusion to Breton's anagram "Avida Dollars".

Dalí never denied his desire for wealth. He could never get enough of fame or money, as he stated in an interview in 1975. And in the forties, both of these achieved untold proportions.

Atomic Melancholy, Uranic Idyll

1945 oil on canvas, 65 x 85 cm Reina Sofia National Museum, Madrid

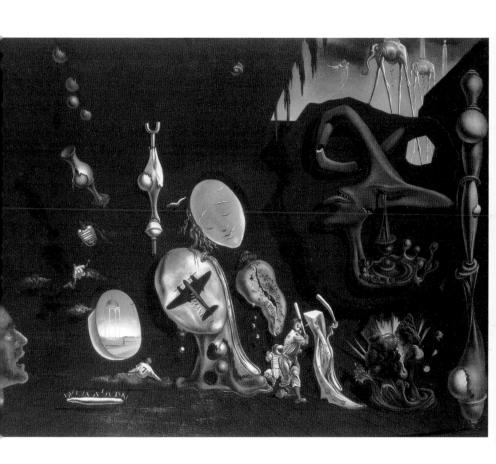

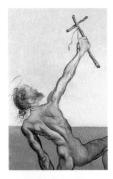

At the end of 1942, the New York Museum of Modern Art put on a retrospective of Dalí's work featuring fifty pictures and seventeen drawings. In December 1942 Dalí met Eleanor and Reynolds Morse. Four months later the Morses bought their first "Dalí" for 1,200 dollars. In the following years the price for his works increased continually. However, the most important source of income for Dalí was not his picture sales, even though some single paintings did sell at up to 300,000 dollars.

The Temptation of Saint Anthony

1946

oil on canvas, 89.7 x 119.5 cm Royal Museums of Fine Arts of Belgium, Brussels

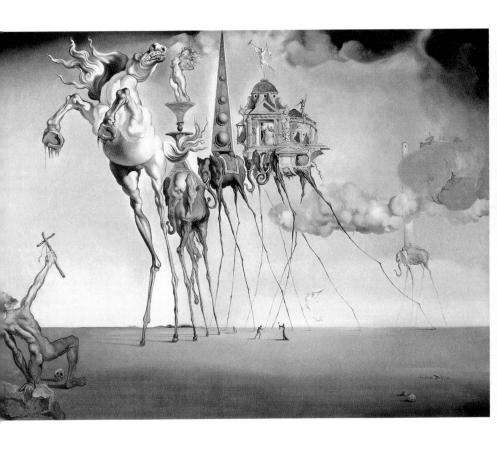

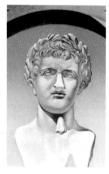

He earned much more from client contracts: he designed ties and ashtrays, created advertisements for perfumes and nylon stockings, designed the title page of the magazines Vogue and Esquire. In the house of the millionaire Helena Rubenstein he painted three large frescoes. He illustrated numerous books, amongst them Cervantes' Don Quixote and Shakespeare's Macbeth. Besides this, Dalí carried on his work in the theater.

Dematerialisation of the Nose of Nero

1947 oil on canvas, 76.2 x 45.8 cm Gala-Salvador Dalí Foundation, Figueras

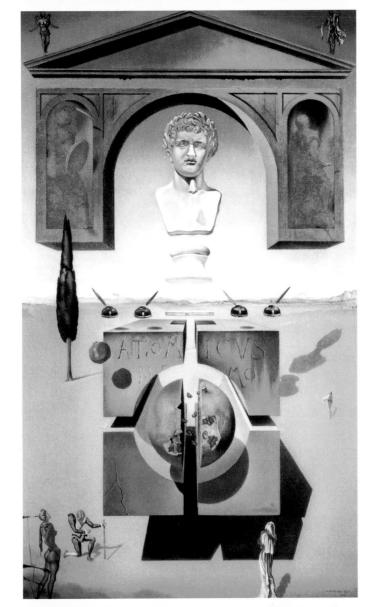

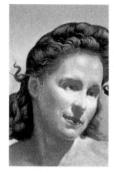

After the performance of his frequently reworked drama *Bacchantal* in 1939, he wrote the libretto for a ballet with motifs from the Ariadne myth. Under the leadership of Leonide Massine, *Labyrinth* was premiered by the Ballets russes at the Metropolitan Opera on October 8th, 1941. The scenery consisted of a gigantic bust of a naked man with a lowered head. On the breast of the man gaped the entrance to the labyrinth. The proximity to Hollywood enticed Dalí back to film again.

Leda Atomica

1949

oil on canvas, 61.1 x 45.6 cm Gala-Salvador Dalí Foundation, Figueras

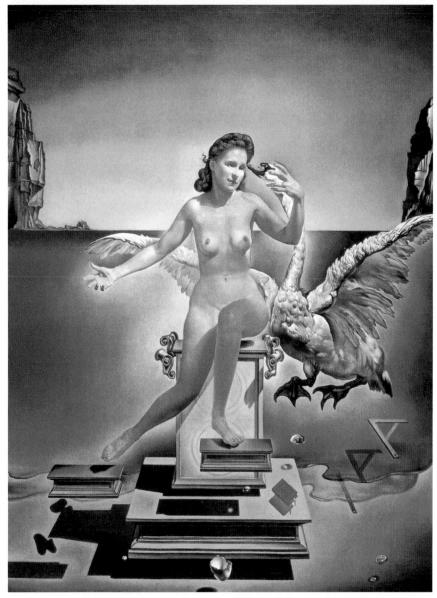

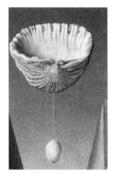

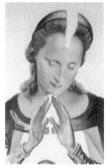

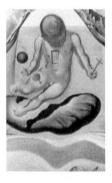

As early as his second visit to the USA in 1936, Dalí had visited the dream factory. In 1945, the director Alfred Hitchcock brought Dalí into the studio to create the dream-sequence for his psychoanalytically inspired film *Spellbound*. Hitchcock had envisaged dream sequences of particular visual sharpness for his film: "Up until this point, the dream-pictures in films had always consisted of a halo surrounded by a whirlpool of puposefully effervescent clouds with people moving back and forth in a mixture of stagesnow and mist.

The Madonna of Port Lligat

1949

oil on canvas, 48.9 x 37.5 cm Marquette University Haggerty Museum of Art, Milwaukee (Wisconsin)

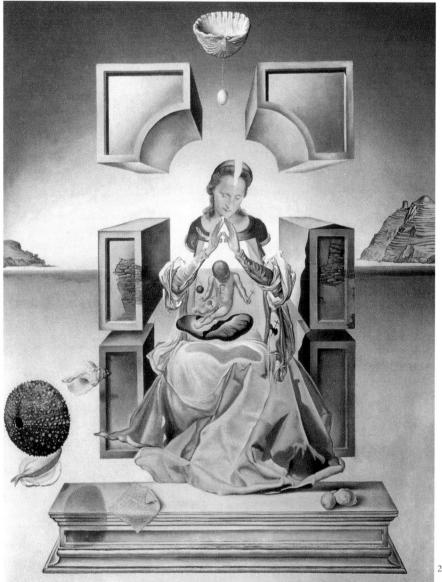

This was the unquestioned norm and I was determined to do the opposite. I chose Dalí [...] because of his ability to paint with hallucinogenic accuracy, which expressed the exact opposite of these evaporations and steamings." Not all of Dalí's ideas were used during the filming, however. For example, the studio refused to hang fifteen pianos from the ceiling. And so Dalí refrained from using the corresponding sequence and created a new setting.

The Madonna of Port Lligat

1950 oil on canvas, 144 x 96 cm private collection, Tokyo

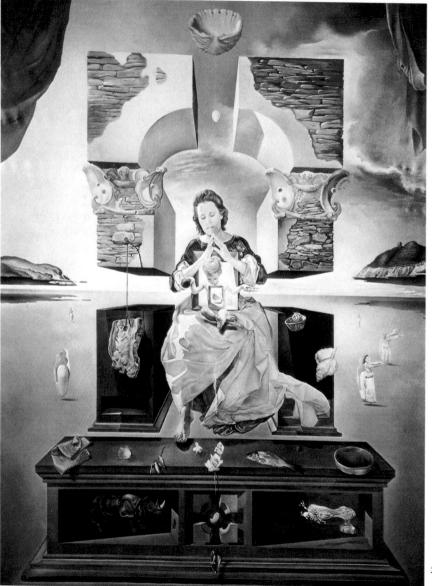

Among other things, the dream-sequence is set in a nightclub, where the curtains are painted with large eyes being cut by a man holding a large pair of scissors - suggestive of the entrance-scene in Un Chien andalou. As a medium, Dalí considered film to be a "secondary form". However, he did become more and more attracted to its technical possibilities. A few months after his successful work with Hitchcock, Walt Disney courted the artist: Dalí was supposed to create a six-minute sequence for an animation film with the title Fantasia.

Study for the Head of The Madonna of Port Lligat

oil on canvas, 49 x 31 cm Salvador Dalí Museum, St Petersburg (Florida)

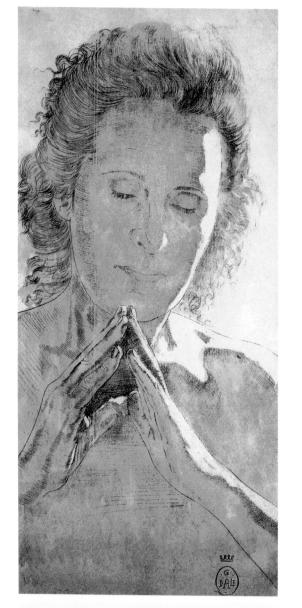

Together with the graphic artist John Hench he developed the screenplay. But then Disney dropped him from the project. In 1950, Dalí worked on another film. He created the dreamsequence for Vincente Minelli's comedy *The Bride's Father*. As a result of these many activities, the painter faded more and more into the background. Dalí's turning to classicism carried itself over onto the screen only marginally.

Raphaelesque Head Exploded

1951

oil on canvas, 43 x 33 cm National Gallery of Scotland, Edinburgh

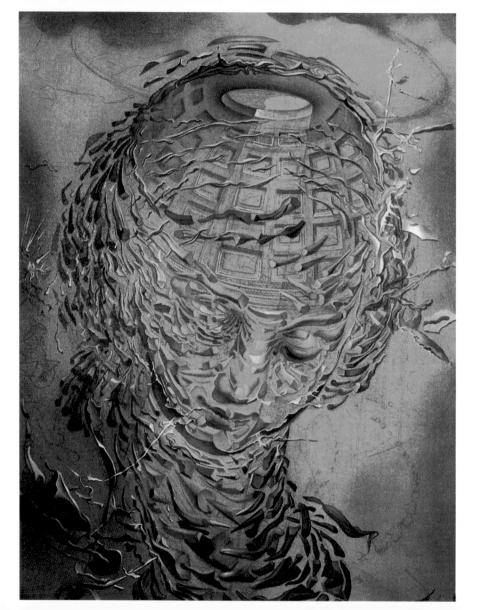

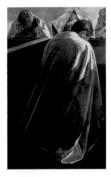

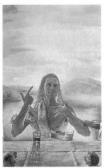

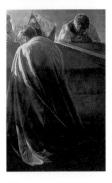

Since his arrival in the USA, Dalí did not come any further with his world design, which proved to be a difficult birth. However, the dropping of the first atomic bomb over Hiroshima gave way to the first contractions: "The explosion of the atomic bomb on August 6th, 1945, jarred me seismically. From this point onwards, the atom became the first object of my considerations. Many landscapes that I painted at this time express the enormous fear I felt on being notified of this explosion." Religion and science became new topics for Dalían painting.

The Last Supper

1955 oil on canvas, 167 x 268 cm National Gallery of Art, Chester Dale Collection, Washington DC

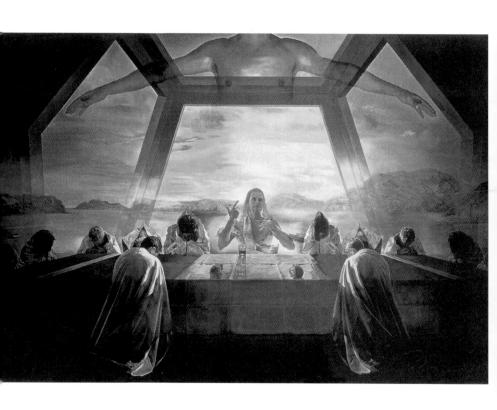

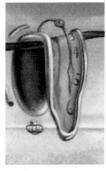

In 1946, he painted his first piece of work with a religious motif: *The Temptation of Saint Anthony*. In Dalí's version, Saint Anthony is threatened by a rearing horse and spindle-legged elephants. In 1948, Dalí converted to the Roman Catholic Church. In the same year he returned once more to Europe.

"Bienvenida a Salvador Dalí": Destino magazine greeted the famous son with this cry as he returned to his fatherland. In 1948, Dalí and Gala moved back into their house in Port Lligat.

Desintegration of the Persistance of Memory

1952-1954 oil on canvas, 25 x 33 cm Salvador Dalí Museum, St Petersburg (Floride)

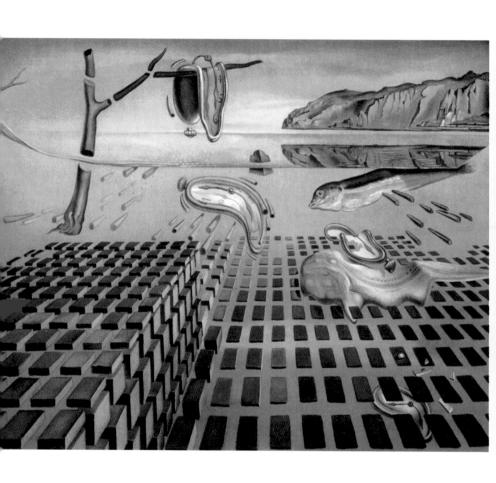

There, in the place that had retained such special meaning for him since his childhood days, Dalí underwent his metamorphosis to sainthood, to the divine:

"On the beach of Port Lligat I realized the Catalonian sun [...] to be the thing that had caused the explosion of the atom of the absolute in me. [...] I understood I was destined to become the saviour of modern painting. I became a saint." After Dalí had raised himself to sainthood, he declared Gala Madonna: with glorified countenance she became the "mother of God" in his paintings.

The Maximum Speed of Raphaëls Madonna

1954 oil on canvas, 81.2 x 66 cm Reina Sofía National Museum, Madrid

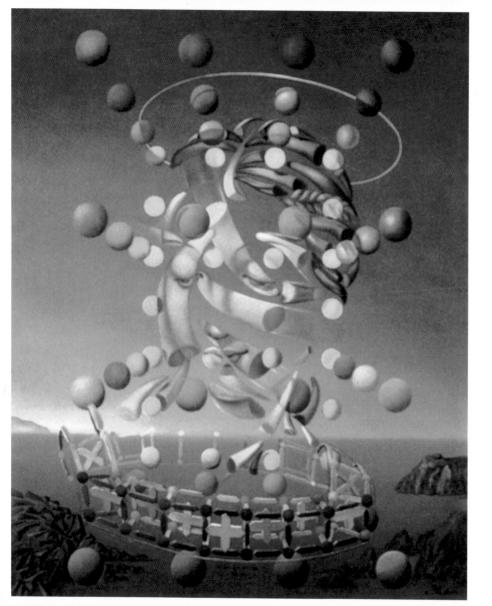

In 1949, he painted the first version of *The Madonna of Port Lligat*. As a model for the painting he used Piero della Francesca's *Madonna with Child* from the 15th century. Dalí attempted to demonstrate the dissolution of gravity in this picture. The Madonna is divided into single body parts, which although unconnected are held in balance and in their correct anatomical positions. The Christ child floats in the open belly, which is also perforated.

Explosion

1954 oil on canvas, 20.5 x 25.7 cm private collection

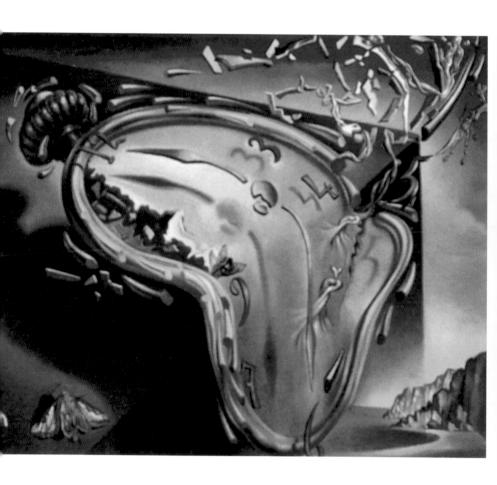

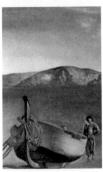

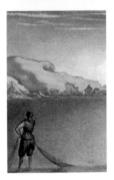

At a private audience with Pope Pius VII in November 1949, Dalí presented the first version of his Madonna. The Pope – as the painter reported, admired the picture greatly. Having reached the pinnacle of his fame, the doors of the mighty now began to open for the Catalonian farmer. And he entered with joy. In 1956, he allowed himself to be received by General Franco, who, eight years later, awarded him the "Cross of Isabel".

Christ of Saint John the Cross

1951 oil on canvas, 205 x 166 Glasgow Art Gallery, Glasgow

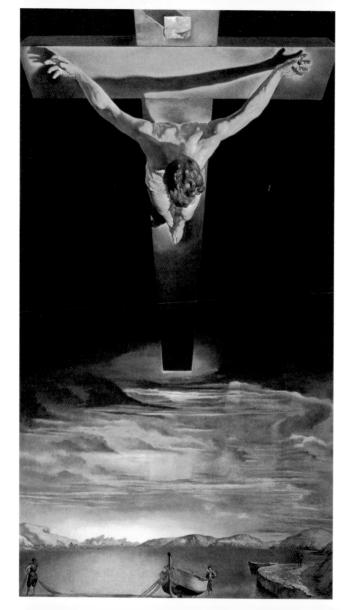

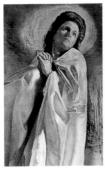

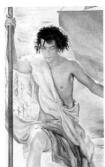

Critics accused him of allowing himself to be honoured by the murderer of his friends, but he rejected this with the answer: "If I have accepted the Catholic 'Cross of Isabel' from the hands of Franco, it is only because nobody in Soviet-Russia has seen fit to award me the Lenin-Prize. And I would also accept an honour if Mao Tse-tung awarded it to me." Dalí stylized his non-political stand to the point of provocation.

The Discovery of America by Christopher Columbus (The Dream of Christopher Columbus)

1958-1959 oil on canvas, 410 x 284 cm Salvador Dalí Museum, St Petersburg (Florida)

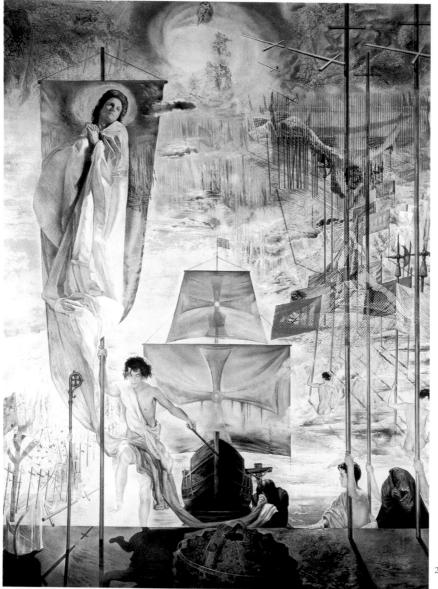

He accepted that a group of artists protested against his participation in an international Surrealist exhibition in New York in 1960: each headline increased his popularity and that was good for business. Television, which he described as the "medium of degradation and feeble-mindedness of the masses", was a means for Dalí to become even better known. Spectacular appearances were still more media-effective than provocative declarations, however.

The Railway Station at Perpignan

1965 oil on canvas, 295 x 406 cm Ludwig Museum, Cologne

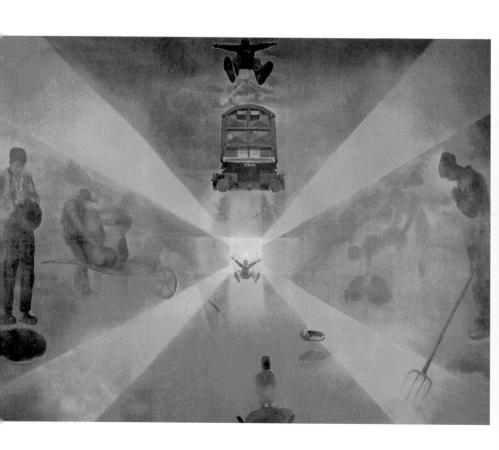

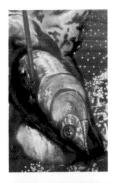

On September 3rd, 1951, Dalí and Gala appeared as seven-metre tall giants at a ball in Venice. The costumes were created by the young Parisian fashion designer Christian Dior. In 1955, Dalí transferred his atelier for some days to the rhinoceros enclosure at the zoo in Vincennes, a suburb of Paris, in order to work on his paranoic-critical version of *The Bobbin-Lace Maker* of Vermeer.

Tuna Fishing

c.1966-1967 oil on canvas, 304 x 404 cm Paul Ricard Foundation, Isle of Bendor

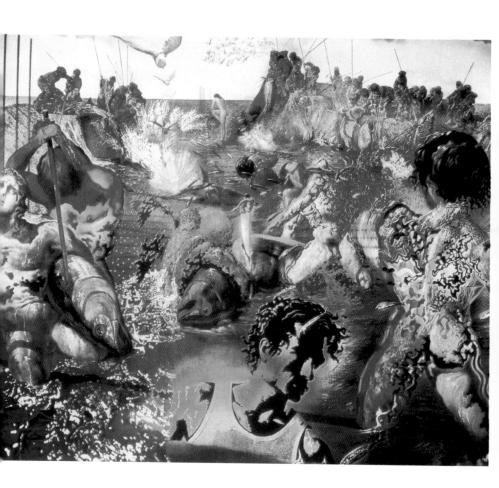

In the eyes of the art-critics Dalí did not just lose credibility because of his promotion in the media. Since his change towards classicism and Catholicism, his paintings had been more negatively assessed. Despite this criticism, almost all the major museums in the world bought Dalí's works in the fifties. At the beginning of the sixties, Dalí began to make plans for a museum in his home town of Figueras.

Mad Mad Minerva

1968

gouache and Indian ink with collage on paper, 61 x 48 cm Kalb Gallery, Vienna

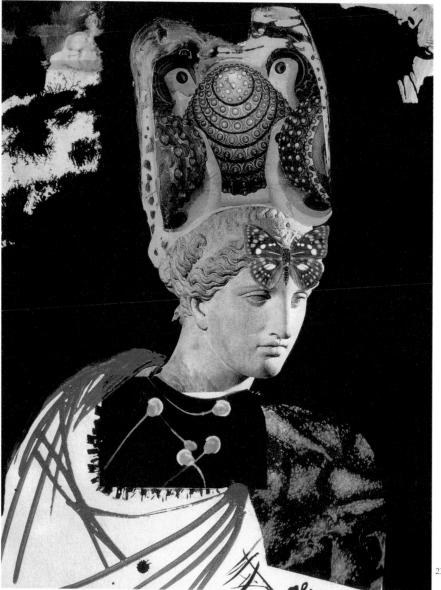

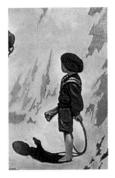

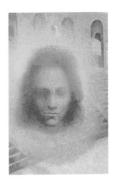

His choice of building was a town theatre, a classical building from the 19th century, and one which had been very badly damaged during the Civil War. At first, Dalí planned to take over the ruins in their damaged state and use them as an exhibition place. In view of the missing roof, however, this proved to be too difficult. Together with the architect Emilio Pérez Piñero, Dalí drafted a dome: "A principle related in particular measure to the monarchy, life and the liturgy."

Hallucinogenic Toreador

c. 1968-1970 oil on canvas, 398.8 x 299.7 cm Salvador Dalí Museum, St Petersburg (Florida)

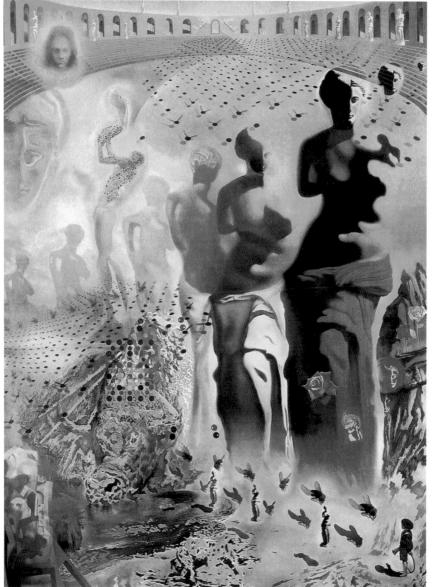

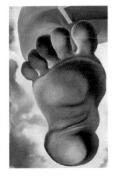

On September 28th, 1974, the seventy-year-old Dalí opened his "Teatro-Museo": it is not just an exhibition place, but also a holy one where the Dalí, the divine, pays homage to himself. He dedicated the dome to Spain's sovereigns – to which the governing dictator Franco also belonged. For Dalí, the time for being honoured began: in 1978, the Spanish royal couple, Juan Carlos and Sofia, visited the "Teatro-Museo".

Wid Palace

1972 ceiling painting of the old Teatro Museo Figueras

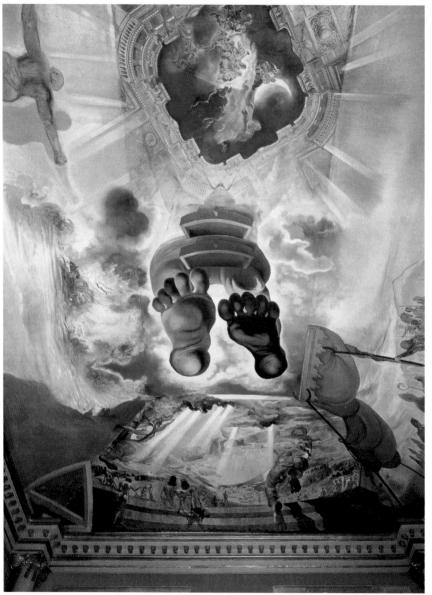

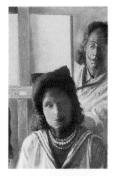

In the same year he was accepted by the French Académie des Beaux-Arts in Paris as an honorary member. The Georges-Pompidou Centre in Paris devoted an extensive retrospective to him in 1979, with over 250 paintings, which was subsequently shown at the Tate Gallery in London. In 1982, the painter was raised to a peerage by King Juan Carlos. And with this, the dream of Dalí's childhood was in one way fulfilled.

Dalí from the Back Painting Gala from the Back Eternalised by six Virtual Corneas Provisionally Reflected in Six Real Mirrors (unfinished)

c. 1972-1973

oil on canvas (stereoscopic work on two components), 60 x 60 cm Gala-Salvador Dalí Foundation, Figueras

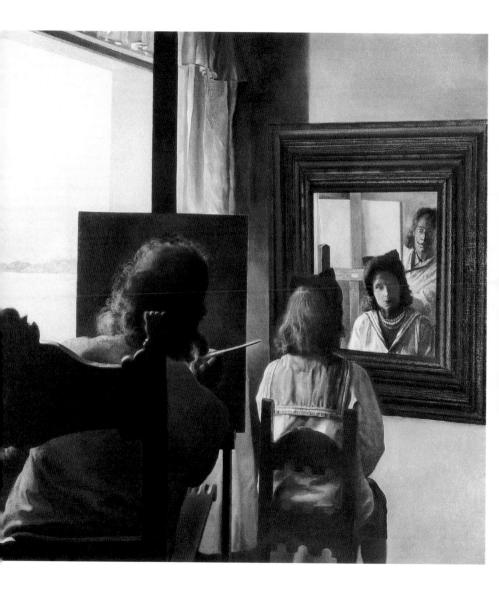

Fame and wealth marked the last twenty years of Dalí's life. From 1970 onwards, his yearly net income was estimated at half a million dollars. For the administration of his "empire", Dalí employed a small court which almost constantly surrounded him. While in interviews, Dalí always claimed he could never have too much of being in the public eye but Gala wished for a place of peace.

Gala's Castle at Púbol

1973 oil on canvas, 160 x 189.7 cm Estrada Museum, Barcelona

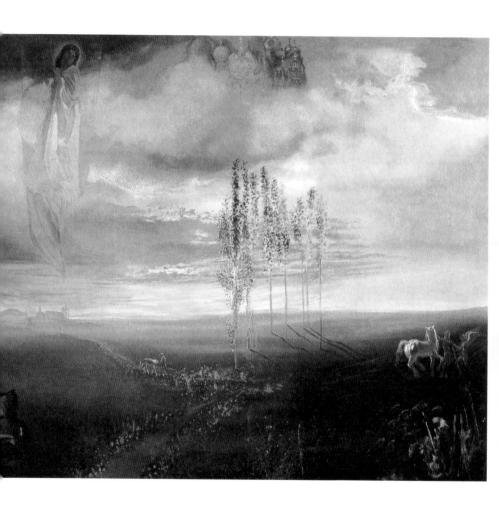

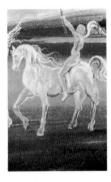

In 1967, Dalí bought the half-ruined Château Pubol for Gala, which they renovated and furnished to their own taste. Here was a place to which Gala retreated more and more frequently. The management of Dalí's general affairs, which had been her task earlier, had been taken over in 1962 by John Peter Moore. Moore, a former officer, was replaced in 1976 by Enrique Sabater. Sabater quickly succeeded in becoming a multi-millionaire at Dalí's expense.

Wounded Soft Watch

1974 oil on canvas, 40 x 51 cm private collection

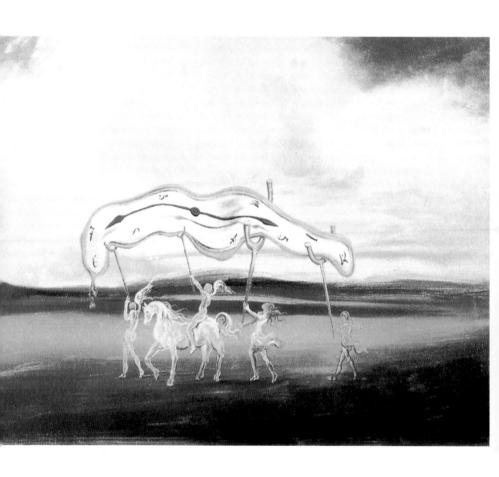

At the beginning of the eighties, Dalí became ill with Parkinson's Disease. He let himself be treated in Paris, and someone spread the rumor that Gala wanted to separate from him. Furthermore, the psychiatrist Dr. Roumeguère, who had treated Dalí over many years, accused Gala in a newspaper article of tyrannizing and hurting her husband. On June 10th, 1982, Gala died of an infection of the ureter.

Equestrian Portrait of Carmen Bordiu-Franco

1974 oil on canvas, 160 x 180 cm private collection

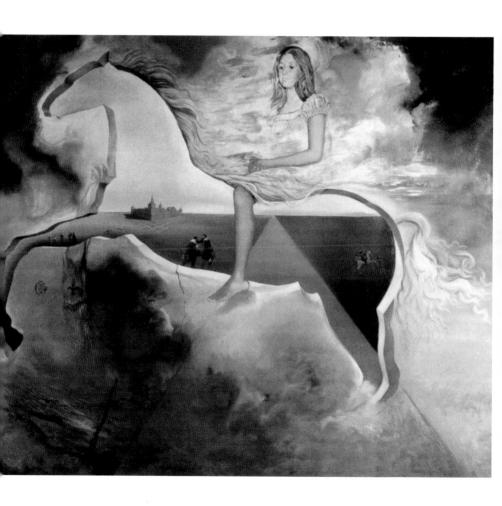

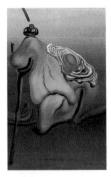

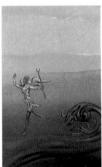

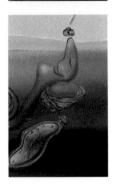

According to her wish, she was laid to rest at Château Pubol. After the burial, Dalí remained at the château, where he lived a secluded life and carried on working despite his illness. Here, in 1983, he painted his last picture: *The Swallow's Tail* – a cloth featuring geometrical signs, which Dalí borrowed from the formulas of the French mathematician René Thom. The upwardly curving ends of the swallow's tail are reminiscent of Dalí's moustache.

Soft Heads with Egg on a Plate without a Plate, Angels, and Soft Monsters in an Angelic Landscape

1977 oil on canvas, 61 x 91.5 cm private collection

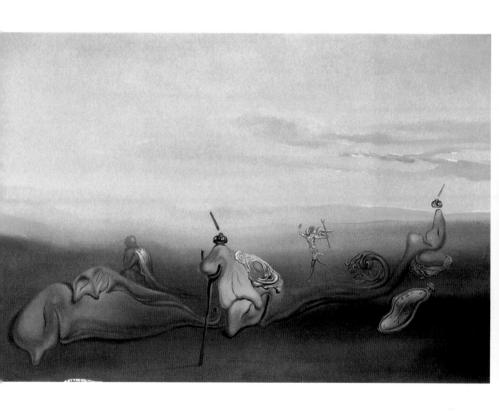

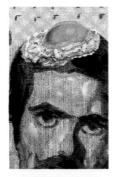

A few months after the completion of the painting a fire broke out at the château, the cause of which has never been identified. Dalí survived the fire badly injured. After his convalescence, he returned to his birthplace and lived beside his "Teatro-Museo" until his death on 23rd January, 1989. He was laid to rest there under the dome. He bequeathed his estate – over two-hundred and fifty paintings and two thousand drawings – to the Spanish state in his last will and testament.

Velásquez Dying Behind the Window on the Left Side out of which a Spoon Projects

> oil on canvas with collages, 75 x 59.5 cm Gala-Salvador DJ8 alí Foundation, Figueras

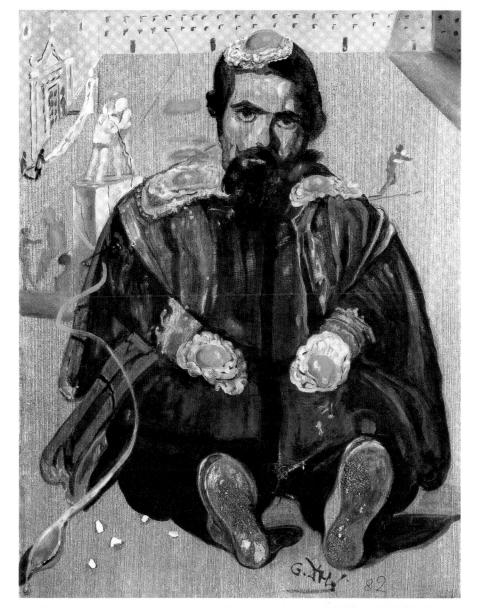

Index

A	
A Couple with their Heads Full of Clouds	157
Anthropomorphic Beach	77
Atavism at Twilight	125
Atomic Melancholy, Uranic Idyll	199
В	
Basket of Bread	65
Bather	73
C	
Cenicitas (Little Cinders)	69
Christ of Saint John the Cross	223
Cover of Minotaure no. 8	163
Cubist Self-Portrait	39
D	
Dalí from the Back Painting Gala from the Back Eternalised by	
six Virtual Corneas Provisionally Reflected in Six Real Mirrors (unfinished)	237
Debris of an Automobile Giving Birth to a Blind Horse Biting a Telephone	167
Dematerialisation of the Nose of Nero	203
Design for the Ball in the Dream Sequence in "Spellhound"	189

Design for the Set of the Ballet Tristan and Isolde	185
Desintegration of the Persistance of Memory	217
Dream Caused by the Flight of a Bee around a Pomegranate,	
One Second before Awakening	183
Dutch Interior (Copy after Manuel Benedito)	9
E	
Equestrian Portrait of Carmen Bordiu-Franco	243
Explosion	221
F	
Family Scene	33
Festival at San Sebastián	29
Fighting the Minotaure	177
Figure at a Window	51
Figure on the Rocks (Sleeping Woman)	57
Fried Eggs on the Plate without the Plate	107
G	
Gala and the Angelus of Millet Preceding the Imminent	
Arrival of the Conical Anamorphoses	119
Gala's Castle at Púbol	239
Galarina	191

Geodesic Portrait of Gala	155
Geological Destiny	113
Geopolitical Child Watching the Birth of the New Man	181
Girl from the Back	61
Н	
Hallucinogenic Toreador	233
Honey is Sweeter than Blood	173
Illuminated Pleasures	89
Impressions of Africa	169
L	
Landscape near Cadaqués	25
Leda Atomica	205
М	
Mad Mad Mad Minerva	231
Mae West's Face which May Be Used as a Surrealist Appartment	137
Masochist Instrument	123
Meditation on the Harp	111
My Wife, Nude, Contemplating her own Flesh Becoming Stairs,	
Three Vertebrae of a Column, Sky and Architecture	193

Portrait of Maria Carbona

Napoleon's Nose, Transformed into a Pregnant Woman,	
Walkinf His Shadow with Melancholia Amongst Original Ruins	195
Night and Day Clothes of the Body	153
P	
Partial Hallucination. Six apparitions of Lenin on a Grand Piano	101
Penya-Segats (Woman on the Rocks)	55
Poetry of America, the Cosmic Athletes	179
Port of Cadaqués at Night	15
Portrait of a Girl in a Landscape	45
Portrait of Ana María	41
Portrait of Gala with Two Lamb Chops Balanced on Her Shoulder	121
Portrait of Hortensia, Peasant Woman from Cadaqués	21
Portrait of José M. Torres	17
Portrait of Lucia	11
Portrait of Luis Buñuel	43

Portrait of My Father	47
Portrait of Paul Éluard	93
Portrait of the Cellist Ricardo Pichot	19
Portrait of the Vicomtesse Marie-Laure de Noailles	109
Profanation of the Host	91
R	
Raphaelesque Head Exploded	213
Remorse or Sunken Sphynx	103
S	
Satirical Composition ("The Dance" by Matisse)	37
Scene in Cabaret	31
Seated Girl from the Back	49
Self-Portrait	27
Self-Portrait in the Studio	13
Self-Portrait with the Neck of Raphael	23
Singularities	145
Soft Construction with Boiled Beans – Premonition of Civil War	149

Soft Heads with Egg on a Plate without a Plate, Angels,	
and Soft Monsters in an Angelic Landscape	245
Soft Self-Portrait with Fried Bacon	175
Study for Honey is Sweeter than Blood	67
Study for the Backdrop of the Ballet Tristan Insane (Act II)	187
Study for the Head of The Madonna of Port Lligat	211
Suburbs of Paranoiac-Critical Town:	
Afternoon on the Outskirts of European History	161
Sun Table	147
Sun, Four Fisherwomen of Cadaqués	71
Surrealist Poster	133
г	
The Angelus of Gala	141
The Anthropomorphic Cabinet	159
The Architectonic Angelus of Millet	115
The Bleeding Roses	95
The Burning Giraffe	151

The Discovery of America by Christopher Columbus

(The Dream of Christopher Columbus)	225
The Enigma of Desire – My Mother, My Mother, My Mother	81
The Enigma of Hitler	171
The Enigma of William Tell	117
The Eye – Design for "Spellbound"	197
The Girl of Ampurdán	59
The Great Masturbator	83
The Horseman of Death	143
The Invisible Man	85
The Knight of Death	131
The Last Supper	215
The Lugubrious Game	87
The Madonna of Port Lligat	207
The Madonna of Port Lligat	209
The Maximum Speed of Raphaëls Madonna	219
The Old Age of William Tell	99
The Persistance of Memory	105
The Railway Station at Perpignan	227

The Sick Child (Self-Portrait in Cadaqués)	35
The Spectre of Sex Appeal	127
The Temptation of Saint Anthony	201
The Weaning of Furniture-Nutrition	135
The Wounded Bird	75
Three Young Surrealist Women Holding in Their	
Arms the Skin of an Orchestra	165
Tuna Fishing	229
U	
Unsatisfied Desires	79
Untitled (William Tell and Gradiva)	97
V	
Velásquez Dying Behind the Window	
on the Left Side out of which a Spoon Projects	247
Vertigo Atavism after the Rain	129
W	
Wid Palace	235
Woman at the Window at Figueras	63
Woman with a Head of Roses	139
Wounded Soft Watch	241